R A N D Y
H A L F O R D

The
ARTSY
Anniversary
COLLECTION

authorHOUSE

AuthorHouse™
1663 Liberty Drive
Bloomington, IN 47403
www.authorhouse.com
Phone: 1 (800) 839-8640

Published by AuthorHouse 08/03/2017

ISBN: 978-1-5462-0228-8 (sc)
ISBN: 978-1-5462-0227-1 (e)

Foreword

I needn't remind you that time goes by staggeringly
fast. You push through with your work. You
publish your first book. Then a second makes it a
franchise. Then you push forward with a third, fourth,
etc. To hear the words "Your tenth book is coming out"
seems almost surreal. I've always held the *hope* that
it might happen. But still, it's like getting stunned in
the forehead with a rubber mallet.
The number ten is a milestone just as much celebrated
in our culture as a silver or golden anniversary.
Another milestone? I have reached the fifty-five mark
in my age, understandably with mixed feelings. So this
is also an anniversary of personal staying power as well
as artistic achievement.
Anyway, let's talk about the book. This one breaks
the record in quantity at 200 cartoons. You'll see the
debut of the "actors", "literature"and "selfie" running series.
Included is a dedication to two dear, terrific people whom
we have recently lost. They have played significant
roles in my life, and *not* mentioning them in this book
would be a crime.
Finally, to all my family, friends and fans who have
followed me down the long and winding road that is
Left Field, I can only express my deepest thanks.
So here's to the future. But wait...you still need to read
this book!
Don't let me stop you! Enjoy!

Yours truly,

Gregory Brucks *Peter Barrett*

To these bright, beautiful souls
who have left this world, this book
is affectionately dedicated...

RANDY HALFORD

{more odds than ends:}
™
LeFT FieLD's

Cartoon Gallery #10

The

ARTSY

Anniversary

COLLECTION

DO NOT TOUCH

1

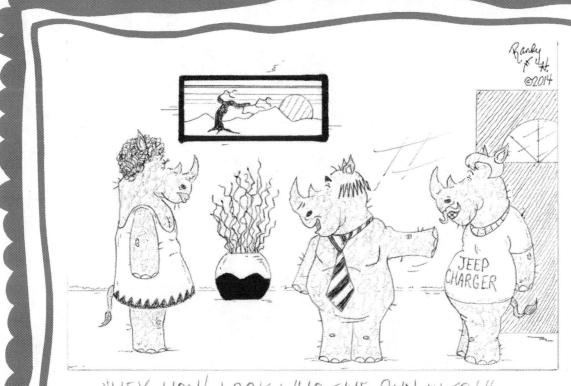

"HEY, HON! LOOK WHO I'VE RUN INTO!"

2

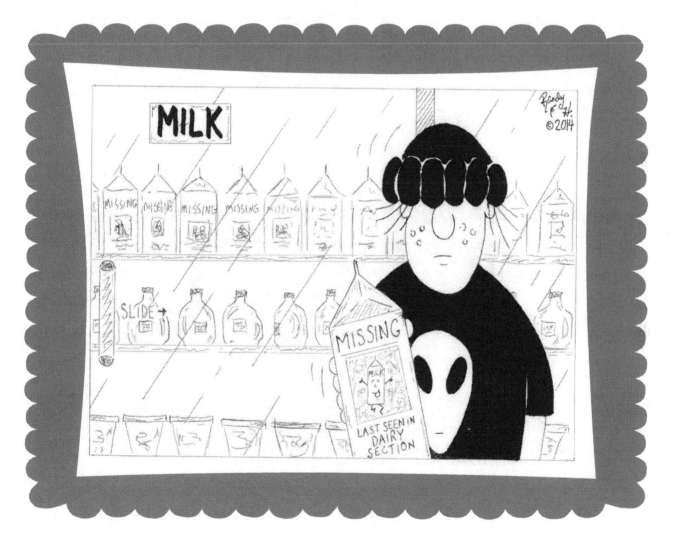

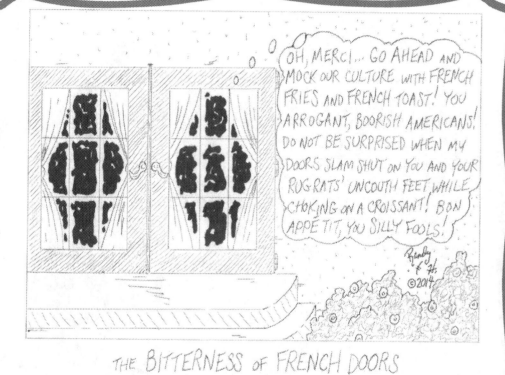

THE BITTERNESS OF FRENCH DOORS

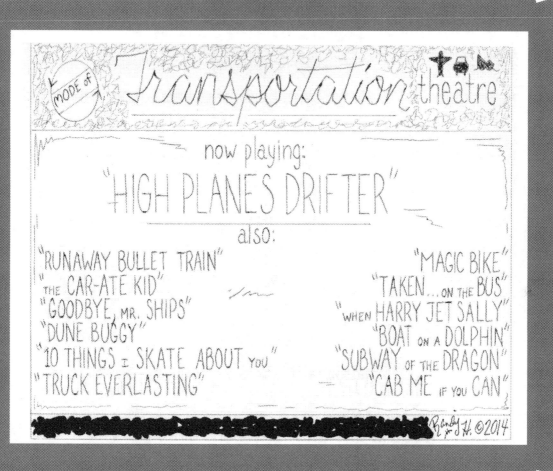

MODE of Transportation theatre

now playing:
"HIGH PLANES DRIFTER"
also:

"RUNAWAY BULLET TRAIN"
"THE CAR-ATE KID"
"GOODBYE, MR. SHIPS"
"DUNE BUGGY"
"10 THINGS I SKATE ABOUT YOU"
"TRUCK EVERLASTING"

"MAGIC BIKE"
"TAKEN...ON THE BUS"
"WHEN HARRY JET SALLY"
"BOAT ON A DOLPHIN"
"SUBWAY OF THE DRAGON"
"CAB ME IF YOU CAN"

Randy H. ©2014

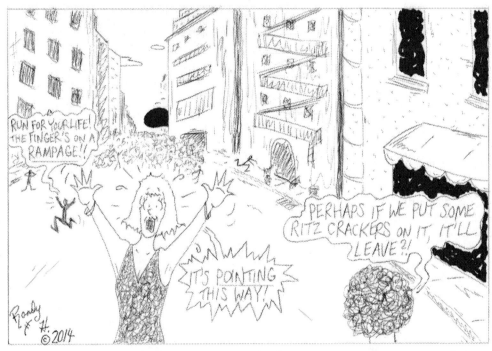

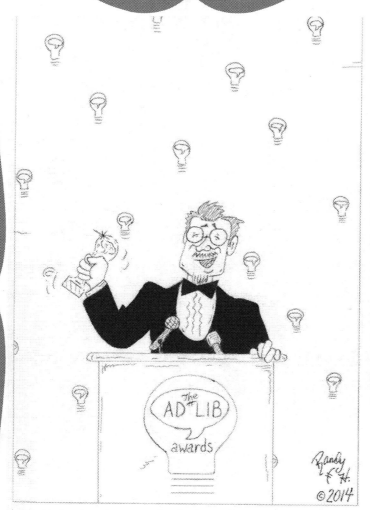

"GOSH, WHAT AN HONOR... THIS IS SO SUDDEN ... I JUST DON'T KNOW WHAT TO SAY..."

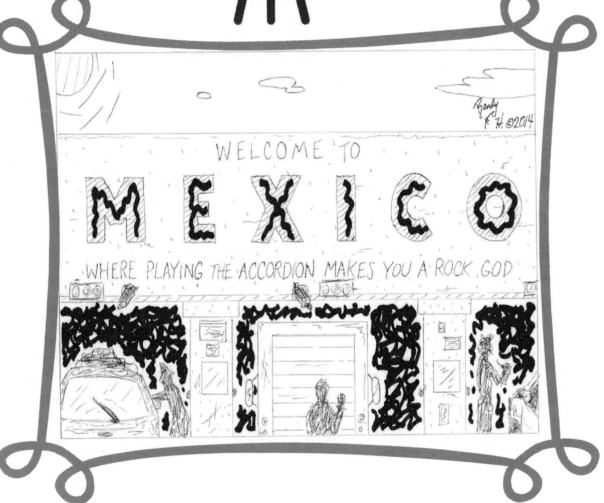

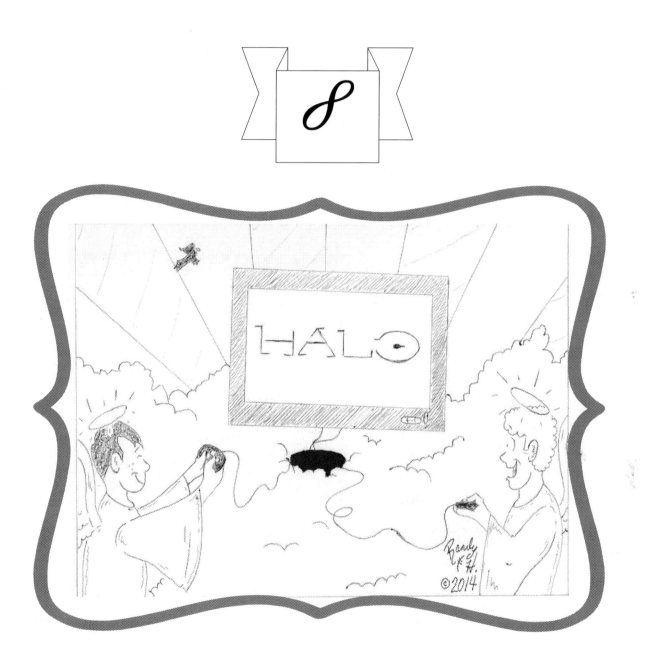

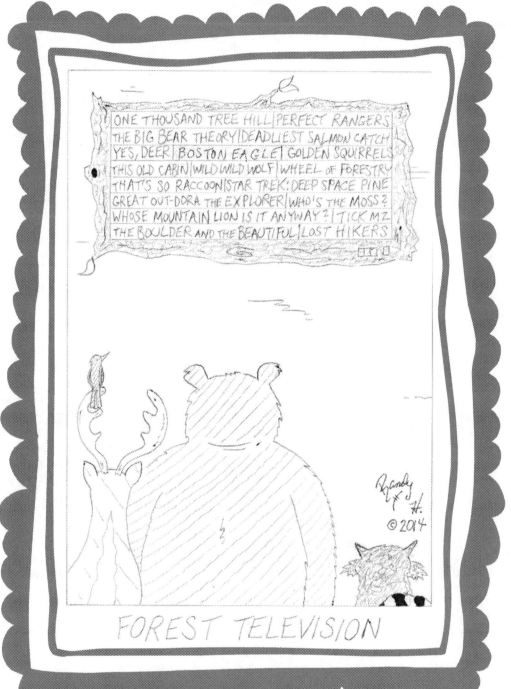

FOREST TELEVISION

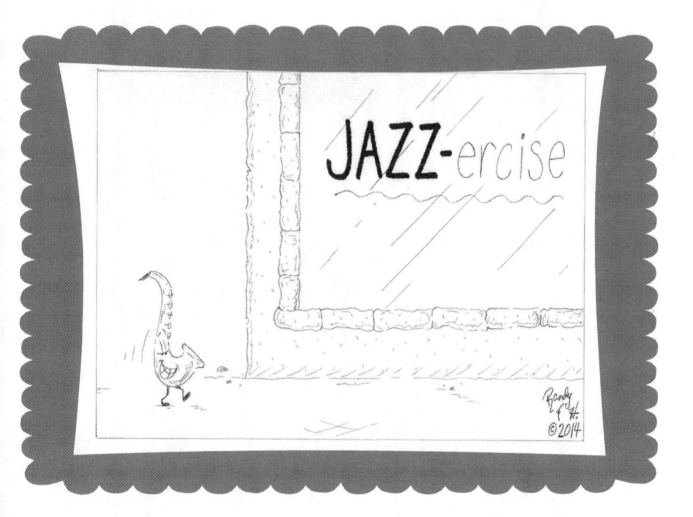

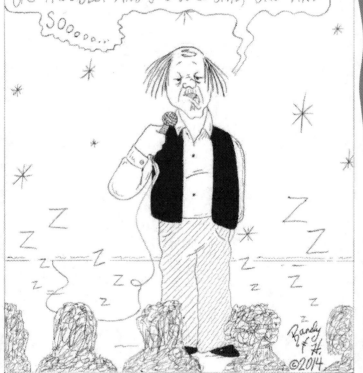

THE RIVETING COMEDY OF ANDY SO

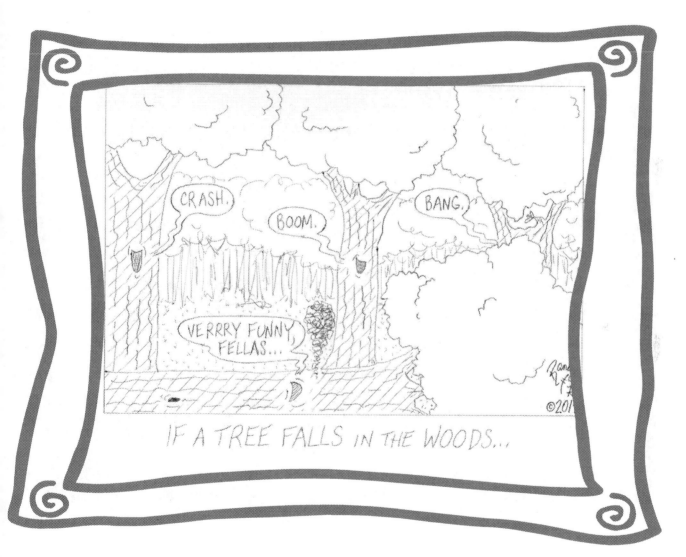

13

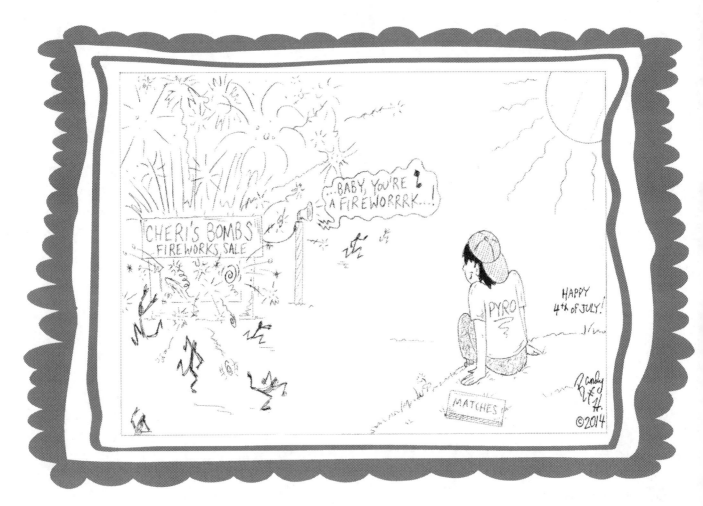

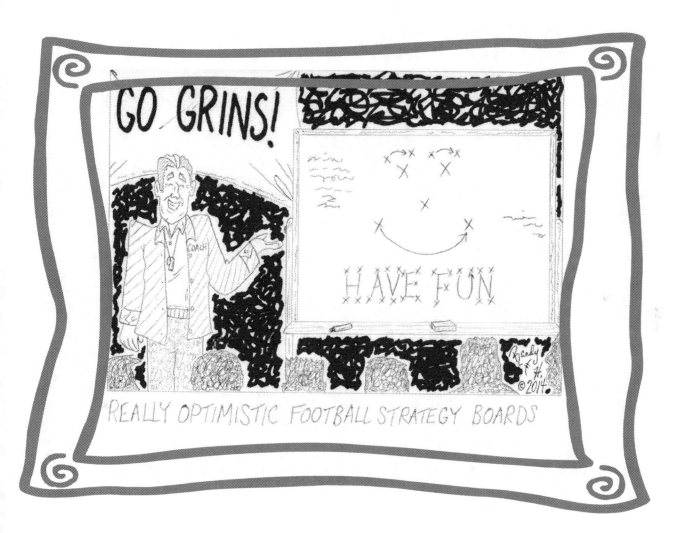

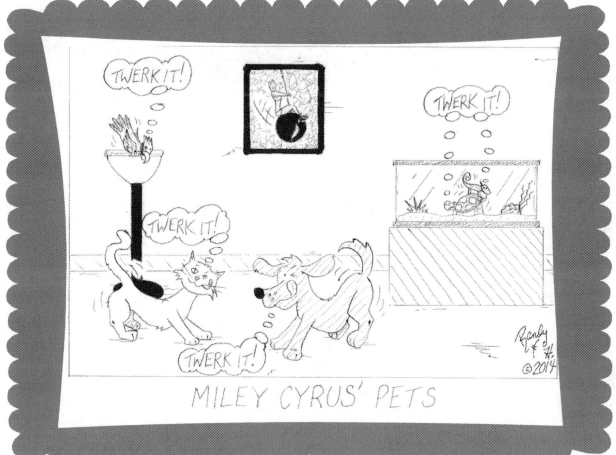

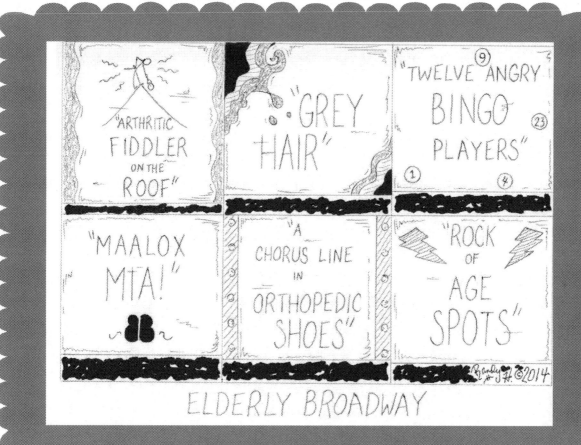

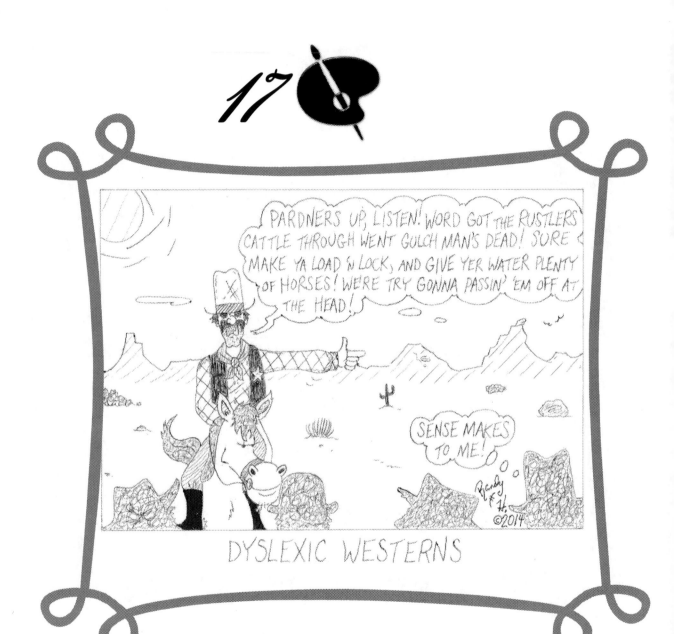

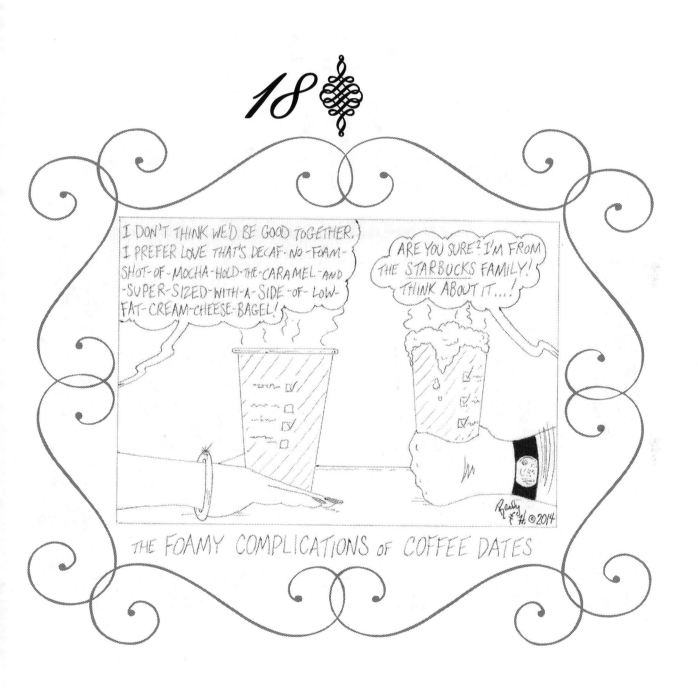

THE FOAMY COMPLICATIONS of COFFEE DATES

NAT KING COLD SORE
PUKE ELLINGTON
RICKY SCABS
GANGRENE DAY
THEY MIGHT BE GIANT ZITS
PINK EYE
ATHLETE'S CHICKENFOOT
MUCUS OF INVENTION
ECZEMA CLAPTON
RUN DIARRHEA MC
PUS PRAIRIE LEAGUE
SUSAN BOIL
CROSBY, STILLS & RASH
SHINGLES BASSEY
NO DOUBT IT'S DISGUSTING

Randy H. © 2014

GROSS JUKE BOXES

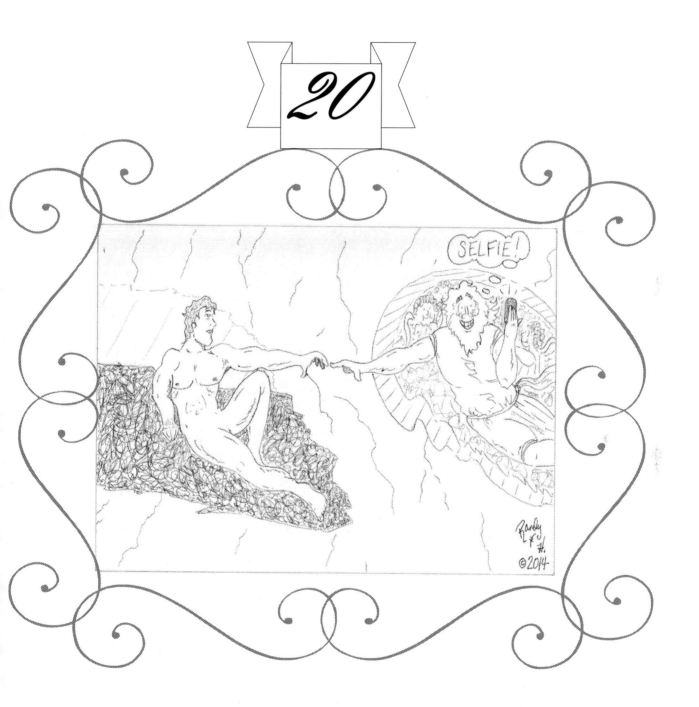

The Coming frames ¹²³⁴⁵⁶⁷ FLICKS

now playing:
"HOW the WEST WAS ONE"

coming soon:
"TWO BE or NOT TWO BE"
"BORN THREE"
"FOUR the LOVE of the GAME"
"the STEPFORD FIVES"
"SIX, LIES, and VIDEOTAPE"
"SEVEN CAN WAIT"
"INDIANA JONES and the EIGHTERS of the LOST ARK"
"NINE of the LIVING DEAD"
"TEN HUR"
"ELEVEN is for REAL"
"TWELFTH TWISTER"
"THIRTEEN with DISASTER"
"KELLY'S ZEROES"

Randy Fch H. ©2014

OUTNUMBERED PICTURES

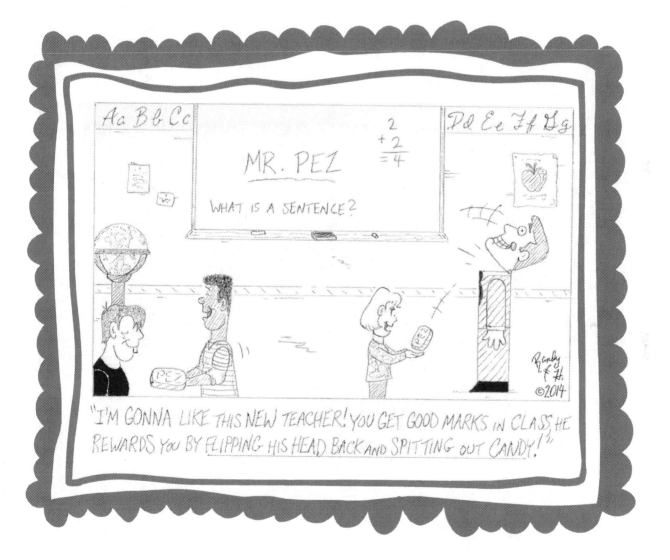

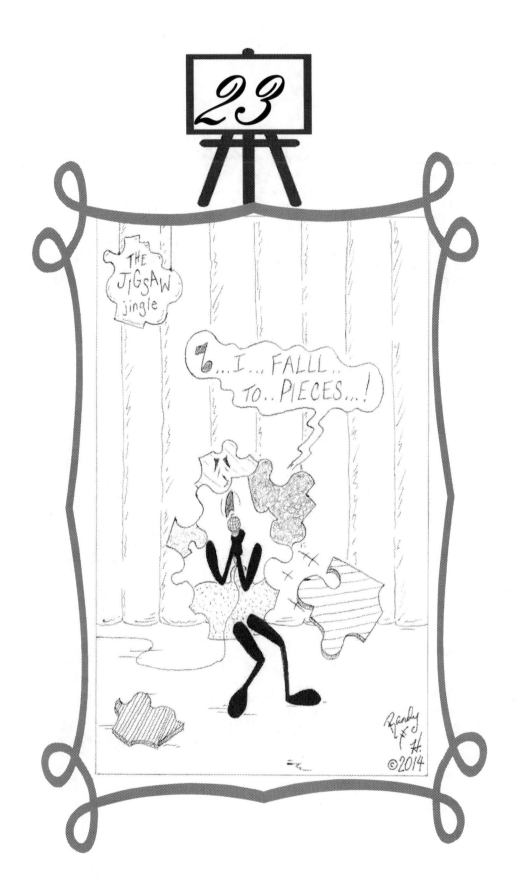

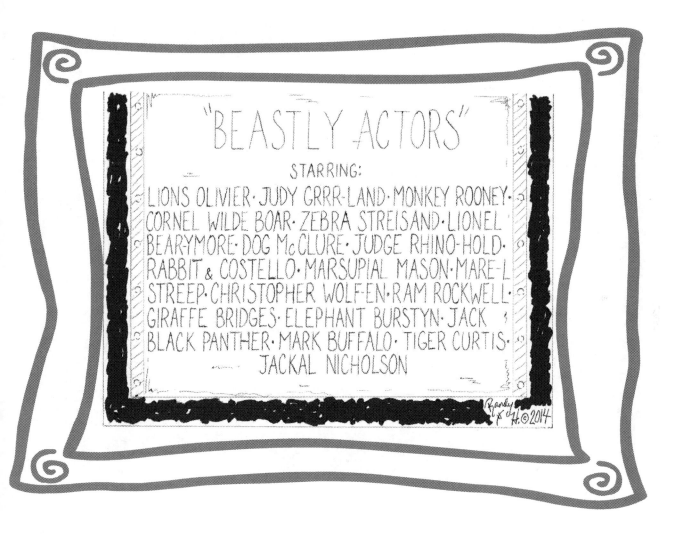

"BEASTLY ACTORS"

STARRING:

LIONS OLIVIER · JUDY GRRR-LAND · MONKEY ROONEY ·
CORNEL WILDE BOAR · ZEBRA STREISAND · LIONEL
BEARYMORE · DOG McCLURE · JUDGE RHINO-HOLD ·
RABBIT & COSTELLO · MARSUPIAL MASON · MARE-L
STREEP · CHRISTOPHER WOLF-EN · RAM ROCKWELL ·
GIRAFFE BRIDGES · ELEPHANT BURSTYN · JACK
BLACK PANTHER · MARK BUFFALO · TIGER CURTIS ·
JACKAL NICHOLSON

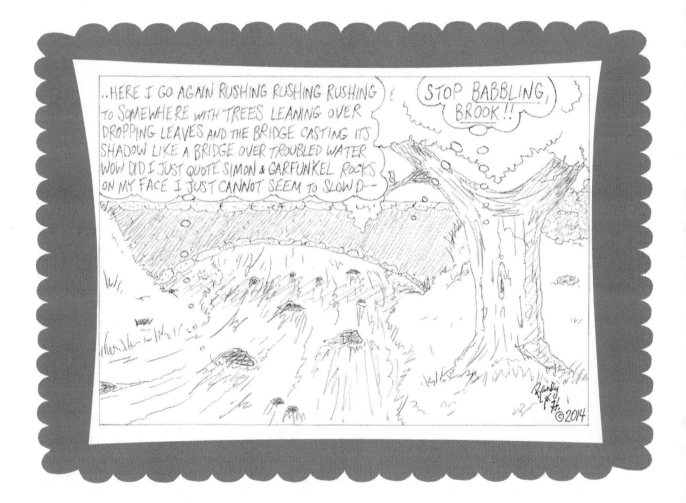

26

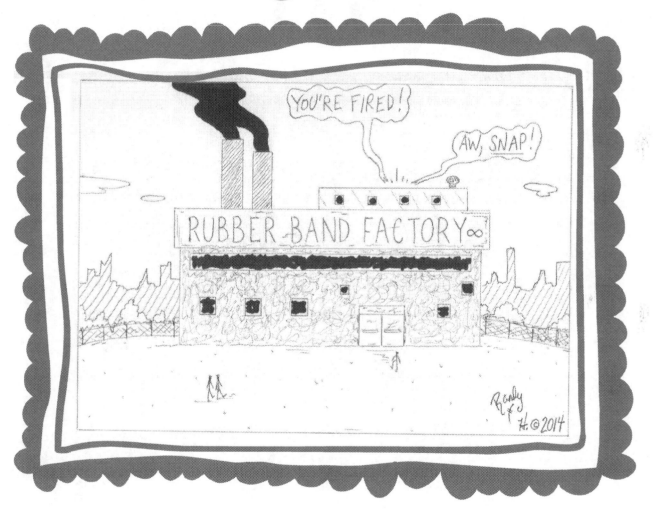

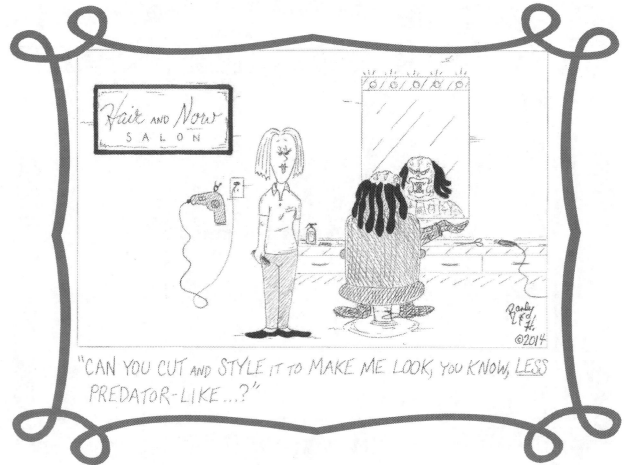

28

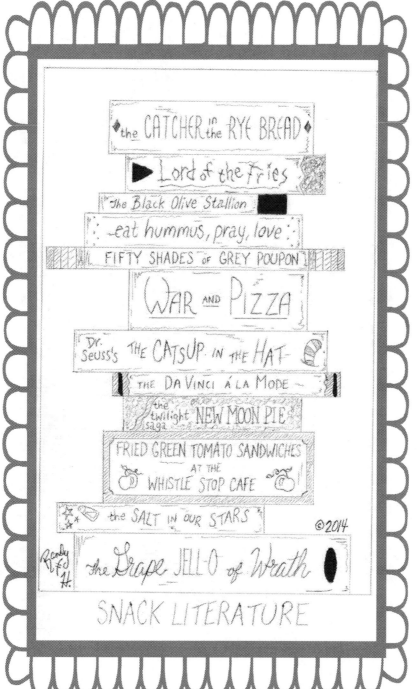

the CATCHER in the RYE BREAD

Lord of the Fries

the Black Olive Stallion

eat hummus, pray, love

FIFTY SHADES of GREY POUPON

WAR and PIZZA

Dr. Seuss's THE CATSUP IN THE HAT

THE Da Vinci á la Mode

the twilight sage NEW MOON PIE

FRIED GREEN TOMATO SANDWICHES
AT THE
WHISTLE STOP CAFE

the SALT IN OUR STARS

©2014

the Grape JELL-O of Wrath

SNACK LITERATURE

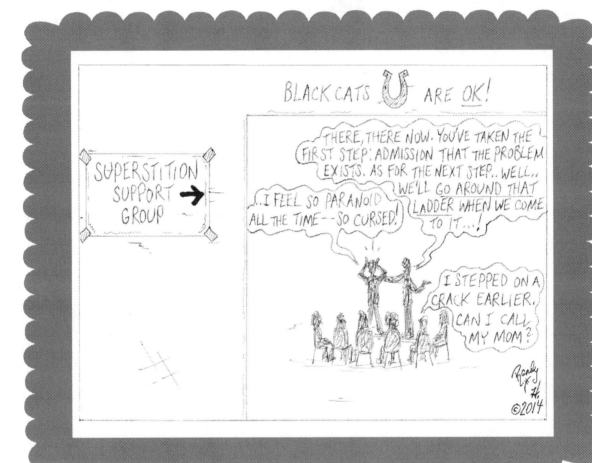

30

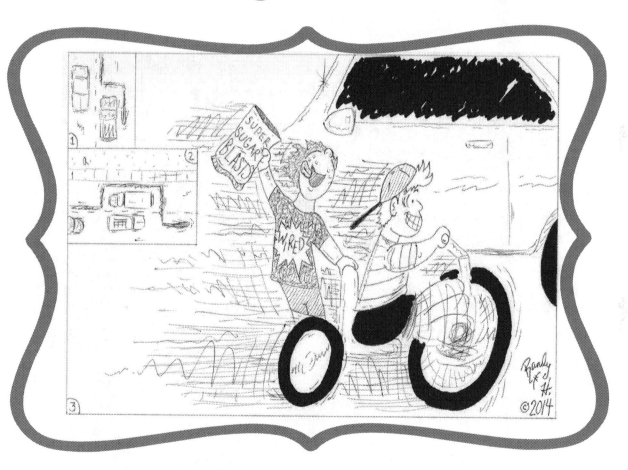

GILLIGAN'S iPOD | GET SMART PHONE | STARGATE 4G
WIDE WIRELESS WORLD OF SPORTS | THE BIG BROAD BAND THEORY
NYPD BLU-RAY | THE TWEET LIFE OF ZACK AND CODY | M
AMERICA'S NEXT LAPTOP MODEL | BLOGGING BAD | MAD HD TV
IMAX SHE WROTE | HOW I UPGRADED YOUR MOTHER | NE
PLASMA HOOD | YOUTUBE CAN'T DO THAT ON TELEVISION
THE INCREDIBLE HULU | FRIENDS ON FACEBOOK | DIGITAL ABBEY
THE BRADY BUNCH OF LIKES | STAR TREK THE TEXT GENERATION

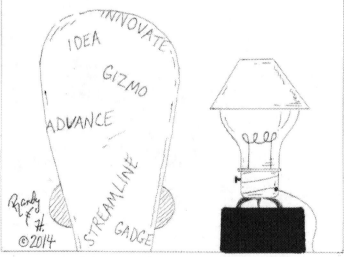

NEW TREND TELEVISION

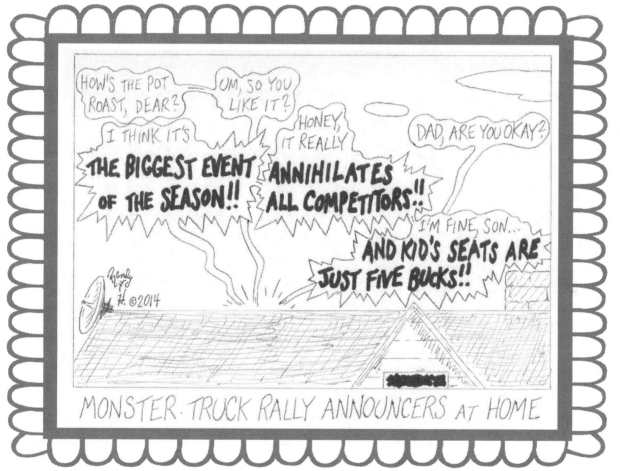

MONSTER-TRUCK RALLY ANNOUNCERS AT HOME

34

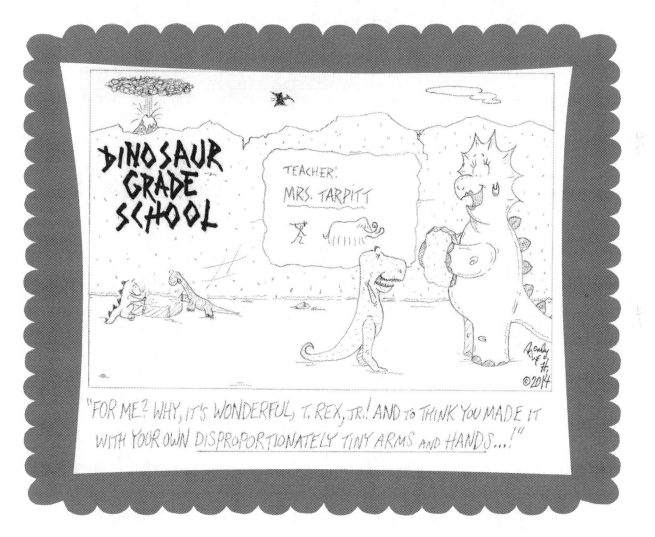

"FOR ME? WHY, IT'S WONDERFUL, T. REX, JR.! AND to THINK YOU MADE IT WITH YOUR OWN DISPROPORTIONATELY TINY ARMS AND HANDS...!"

brats movie house

now playing:
"WHERE the TOYS ARE"

coming soon:
"CHOCOLÁT MOUTH"
"PLANES, TRICYCLES and AUTOMOBILES"
"MINOR REPORT"
"DIRTY HANDS HARRY"
"GEORGE of the JUNGLE GYM"
"SHRILL NOISES OFF!"
"FUNNY FRECKLED FACE"
"TRAINING WHEEL DAY"
"DAYS of WHINE and ROSES"
"SILVER LININGS PLAYGROUND"
"PEE-WEE'S BIG TANTRUM ADVENTURE"
"BRAT on a HOT TIN ROOF"
"SCOOTER PILGRIM vs. the WORLD"
"SIBLING FIGHT CLUB"

Randy F.H. ©2014

KID FLICKS

36

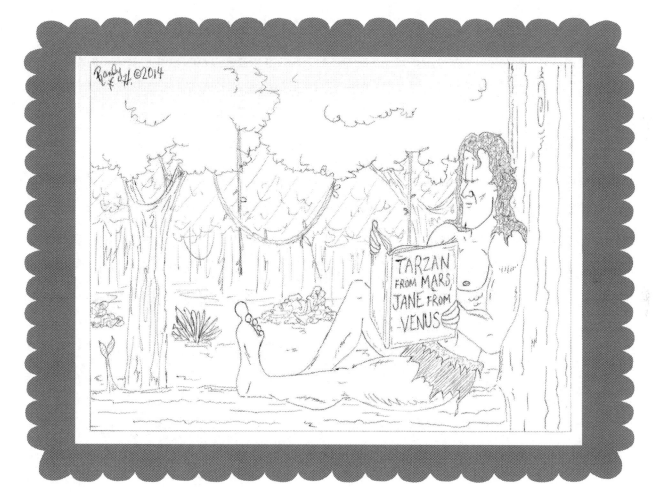

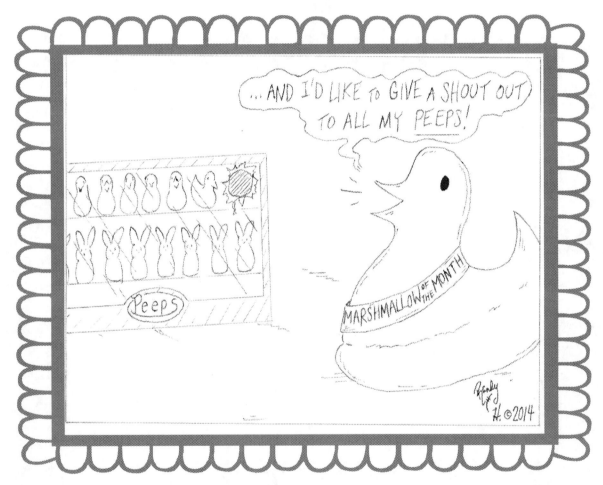

38

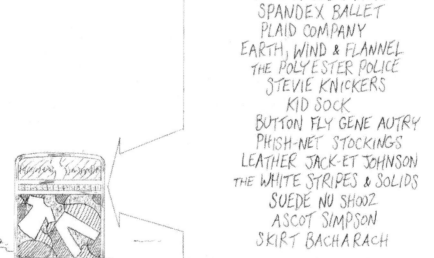

CORDUROY ORBISON
FLEETWOOD MACK
SPANDEX BALLET
PLAID COMPANY
EARTH, WIND & FLANNEL
THE POLYESTER POLICE
STEVIE KNICKERS
KID SOCK
BUTTON FLY GENE AUTRY
PHISH-NET STOCKINGS
LEATHER JACK-ET JOHNSON
THE WHITE STRIPES & SOLIDS
SUEDE NU SHOOZ
ASCOT SIMPSON
SKIRT BACHARACH

FASHIONABLE JUKE BOXES

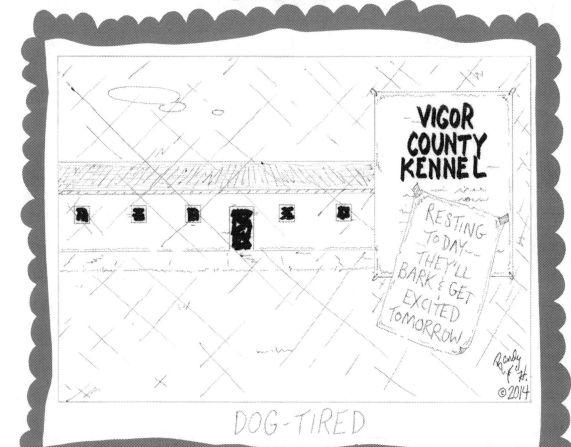

DOG-TIRED

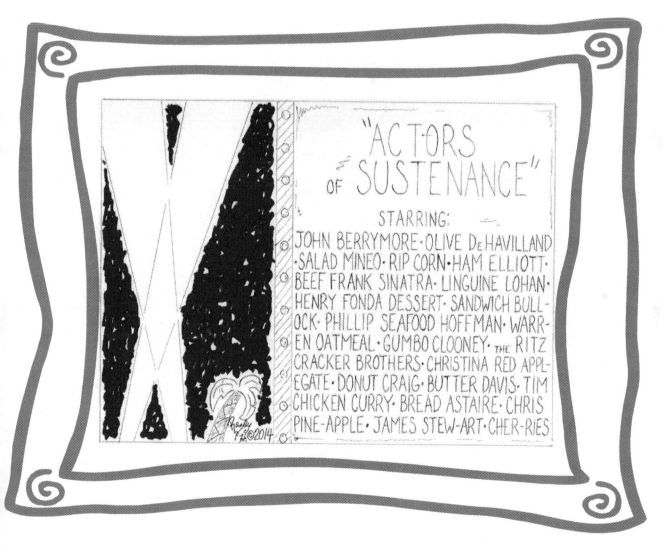

"ACTORS of SUSTENANCE"

STARRING:

JOHN BERRYMORE · OLIVE De HAVILLAND · SALAD MINEO · RIP CORN · HAM ELLIOTT · BEEF FRANK SINATRA · LINGUINE LOHAN · HENRY FONDA DESSERT · SANDWICH BULLOCK · PHILLIP SEAFOOD HOFFMAN · WARREN OATMEAL · GUMBO CLOONEY · THE RITZ CRACKER BROTHERS · CHRISTINA RED APPLEGATE · DONUT CRAIG · BUTTER DAVIS · TIM CHICKEN CURRY · BREAD ASTAIRE · CHRIS PINE-APPLE · JAMES STEW-ART · CHER-RIES

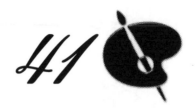

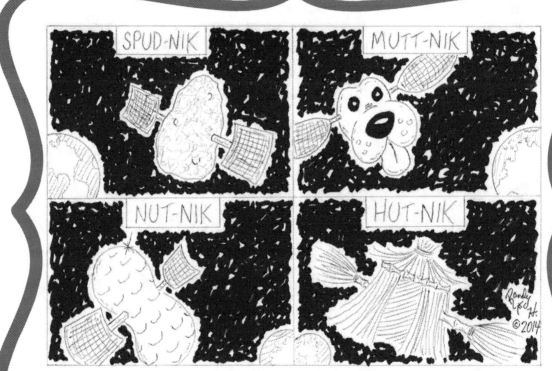

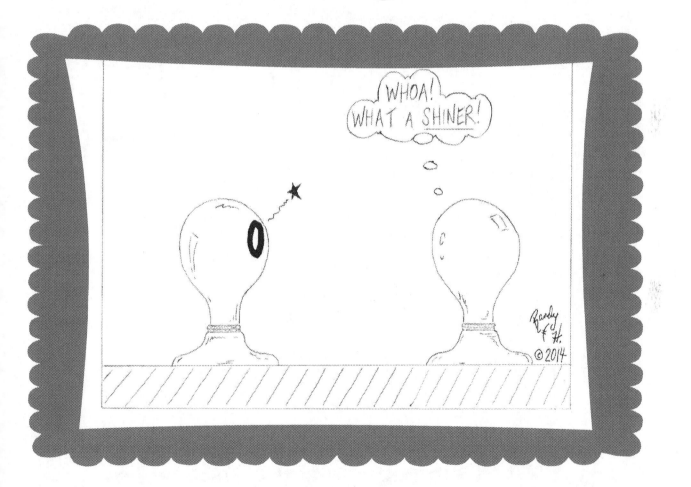

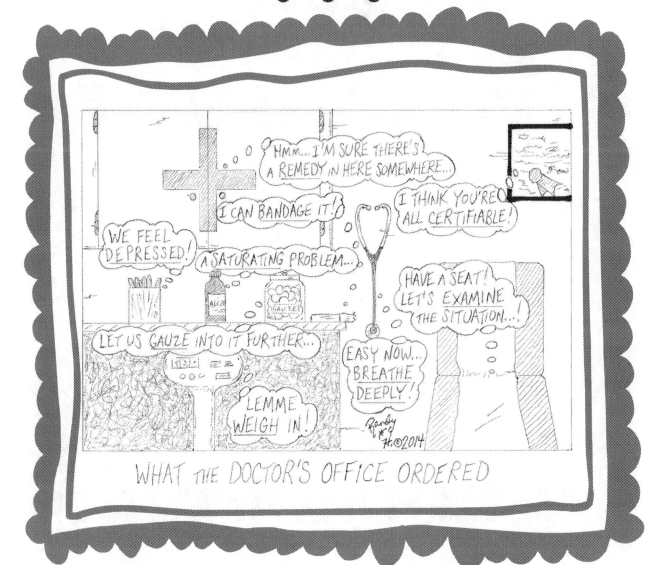

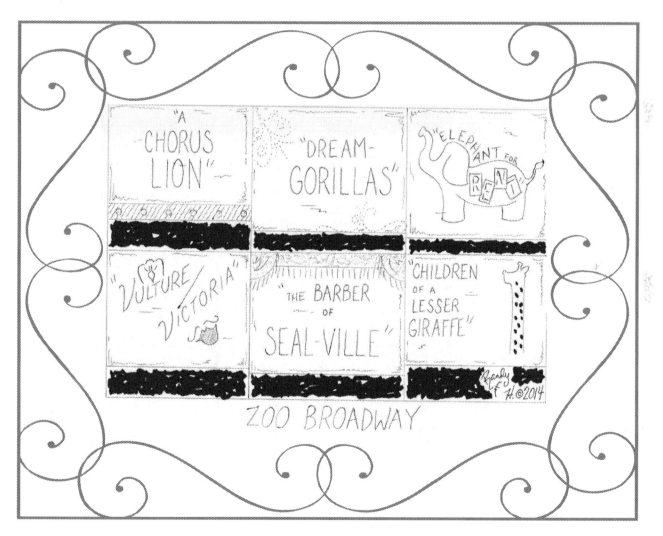

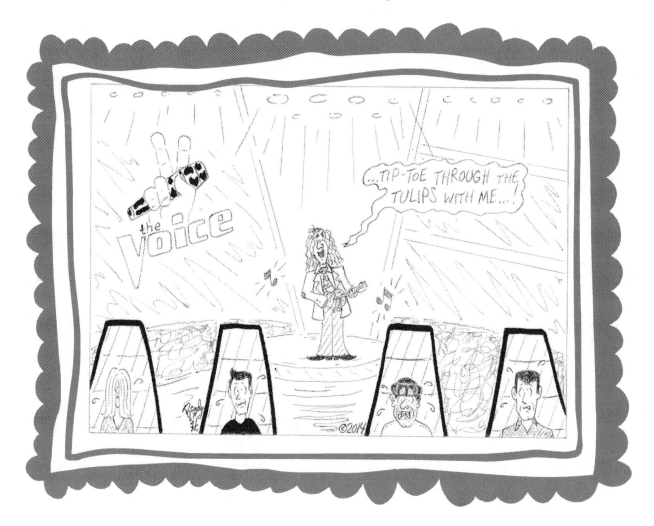

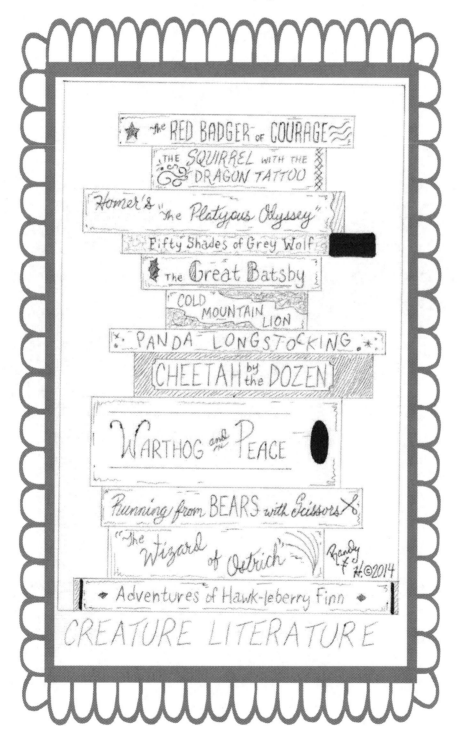

- the RED BADGER of COURAGE
- THE SQUIRREL WITH THE DRAGON TATTOO
- Homer's "the Platypus Odyssey"
- Fifty Shades of Grey Wolf
- the Great Batsby
- COLD MOUNTAIN LION
- PANDA LONGSTOCKING
- CHEETAH by the DOZEN
- WARTHOG and PEACE
- Running from BEARS with Scissors
- "the Wizard of Ostrich"
- Adventures of Hawk-leberry Finn

Randy F H. ©2014

CREATURE LITERATURE

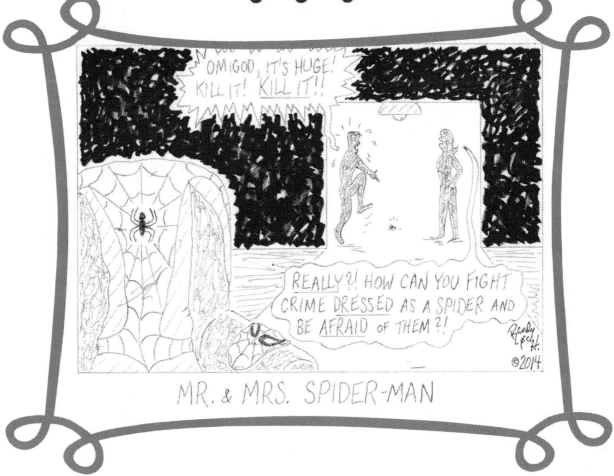

MR. & MRS. SPIDER-MAN

Trashy television

↓

GREEN GARBAGE ACRES | FAMILY FLIES | NEWS
LANDFILL OF THE LOST | DUMPING WITH THE STARS
GOMER PYLE OF REFUSE, USMC | JUNKY KIMMEL LIVE
FRANKLIN & TRASH | DOWNTON ABBEY RUBBISH |
LIVE WITH SMELLY AND MICHAEL | LAW & BAD ODOR
ROTTEN JERSEY SHORE | 21 JUNK STREET | KA
WENDY WILLIAMS MOVES DOWNWIND | MAGNUM, PU
DR. LANDPHIL | HOW I HEFTY-BAGGED YOUR MOTHER |

Randy F. H. ©2014

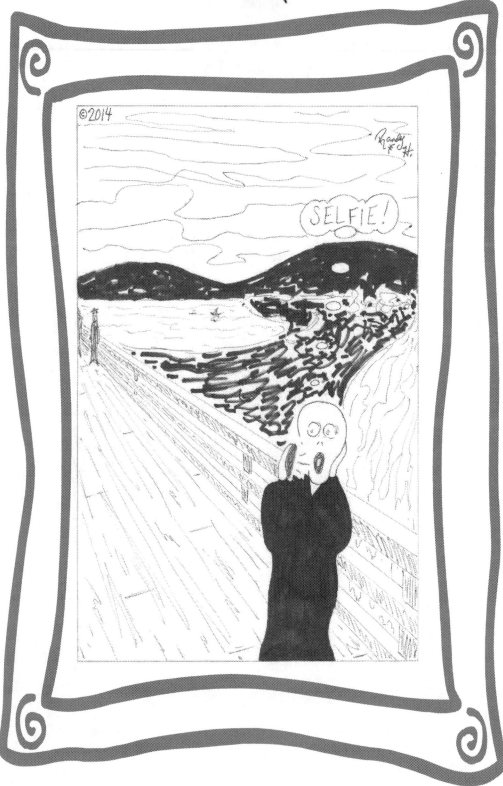

Liquid PARADISE ○ *flicks*

now playing:
"STAR TREK: THIRST-CONTACT"

coming soon:

"THE SECRET LIFE OF WATER MITTY"
"A CLOCKWORK ORANGE CRUSH"
"THE SODA POP OF GREENWICH VILLAGE"
"RED BULL DURHAM"
"INDIANA JUICE AND THE LAST KOOL-AID"
"COLD MOUNTAIN DEW"
"THE BLUE ICEE LAGOON"
"THE GREAT WALDO DR. PEPPER"
"DIET DRINK ANOTHER DAY"
"GATOR-ADE"
"THE BAD NEWS ROOT BEERS"
"THE SNAPPLE DUMPLING GANG"
"ICED TEA WITH MUSSOLINI!"
"THE LEMONADE DROP KID"
"STARBUCKS AND THE PREACHER"
"DIVINE SECRETS OF THE YOO-HOO SISTERHOOD"
"MAGIC MILK"

Ranky ©2014

QUENCHABLE FEATURES

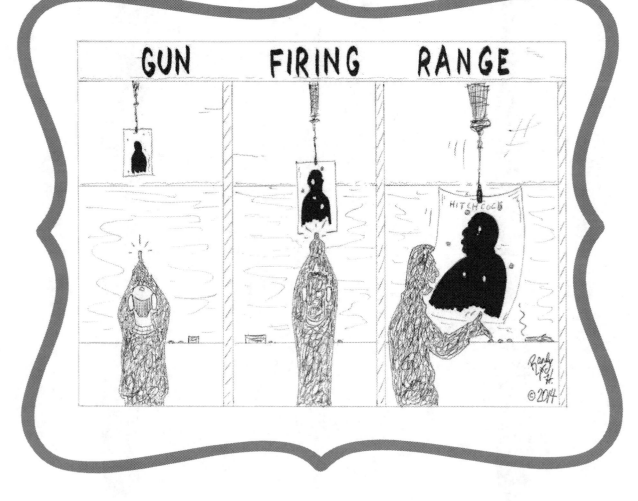

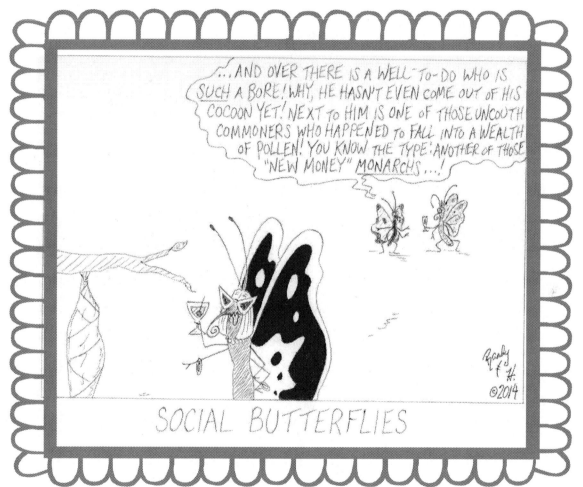

53

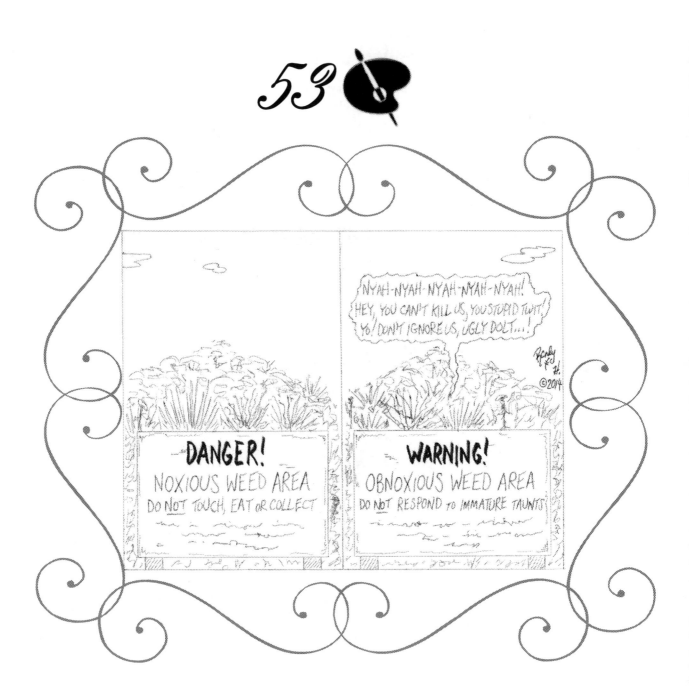

54

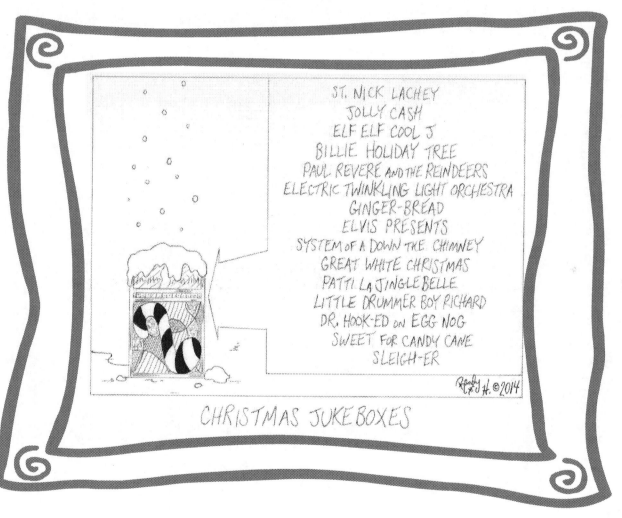

ST. NICK LACHEY
JOLLY CASH
ELF ELF COOL J
BILLIE HOLIDAY TREE
PAUL REVERE AND THE REINDEERS
ELECTRIC TWINKLING LIGHT ORCHESTRA
GINGER-BREAD
ELVIS PRESENTS
SYSTEM OF A DOWN THE CHIMNEY
GREAT WHITE CHRISTMAS
PATTI La JINGLE BELLE
LITTLE DRUMMER BOY RICHARD
DR. HOOK-ED ON EGG NOG
SWEET FOR CANDY CANE
SLEIGH-ER

CHRISTMAS JUKE BOXES

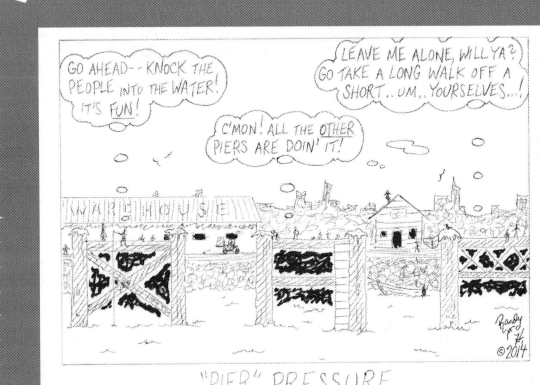

56

CINEMA 2/6

"AUTO ACTORS"

STARRING:

FORD MacMURRAY · CHEVROLET CHASE · BMW.
C. FIELDS · CHRYSLER HEMSWORTH · LINCOLN
LOHAN · DODGE JOHNSON · LIAM NISSAN · FIAT
MURRAY ABRAHAM · SUBARU SARANDON ·
RICHARD GEAR · TIRE PERRY · CADILLAC
DENEUVE · JANE HONDA · ENGINE DICKINSON
· TOYOTA HANKS · MERCEDES BENZ STILLER ·
JOHN HOODMAN · DANNY DeSOTO · EDSEL HAR-
RIS · TOM CRUISE CONTROL · ROBERT VOLKS-
WAGONER · WHEEL SMITH · HEADLIGHT LA-
MARR · VIN DIESEL TRUCK · BUICK VAN DYKE

Randy H. ©2014

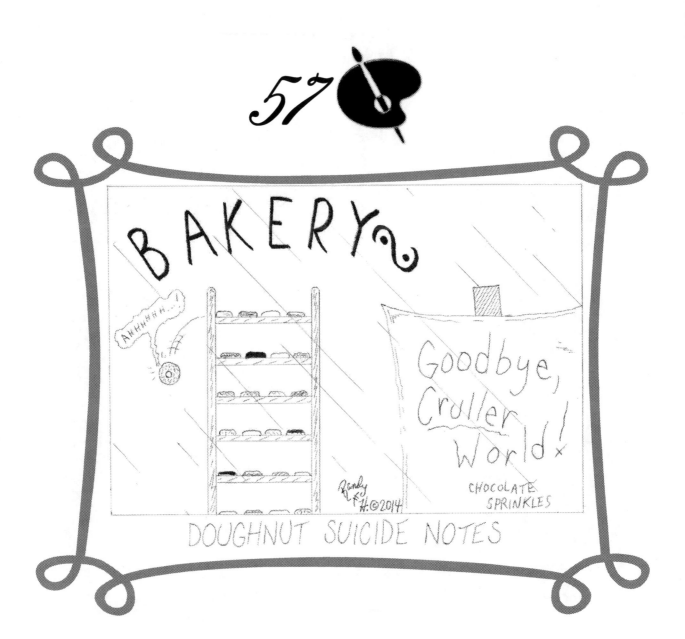

58

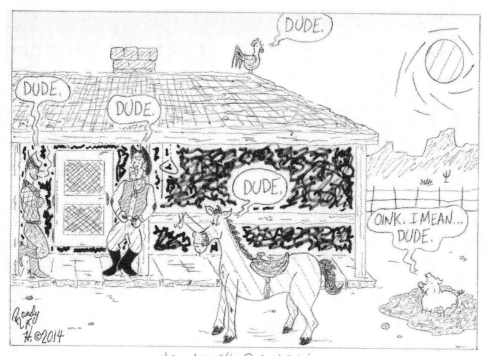

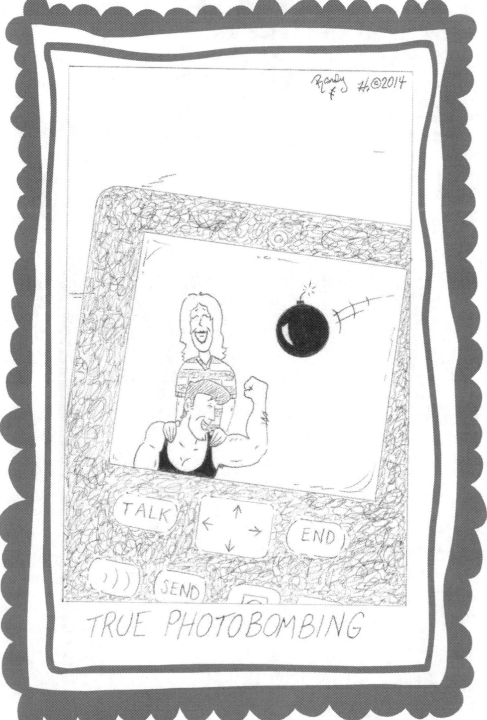

TRUE PHOTOBOMBING

UNBELIEVABLY ABSENT-MINDED GAMESHOWS

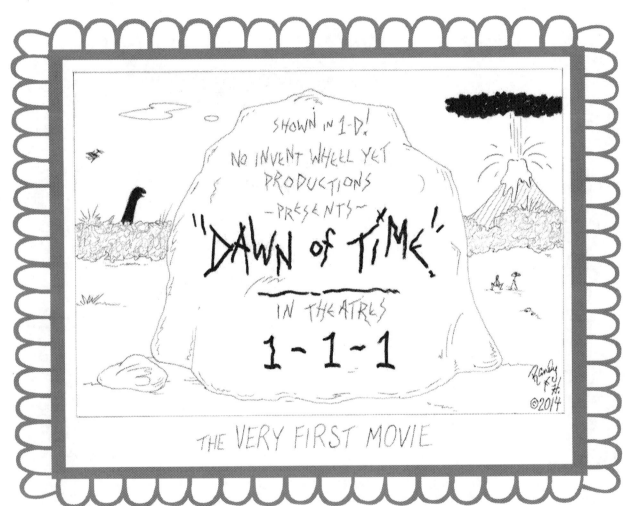

"MY FERRET LADY"

"THE COLOR PEACOCK"

"BIG STRIPED CATS"

"CROC OF AGES"

ZOO BROADWAY, PART 2

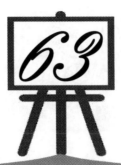

63

THE ST. PATTY DUKE SHOW | QUANTUM LEPRECHAUN
I DREAM of JEANNIE with RED HAIR | BLARNEY MILLER
POT 'O GOLDEN GIRLS | PROJECT GREEN RUNWAY IN
MURPHY O'BROWN | THIS OLD PUB | IRISH CASTLE!
THE COBBLED STREETS of SAN FRANCISCO | WW FINIAN
THE GRINNIN' HONEYMOONERS | MR. LUCKY CHARMS
HOW I DRANK YOUR MOTHER UNDER THE TABLE!
SO YOU THINK YOU CAN DANCE A JIG | GREEN ACRES of CLOVER

IRISH TELEVISION

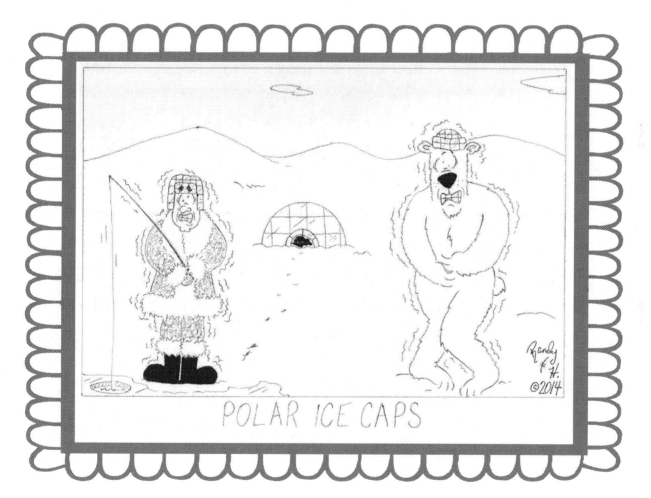

65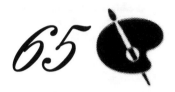

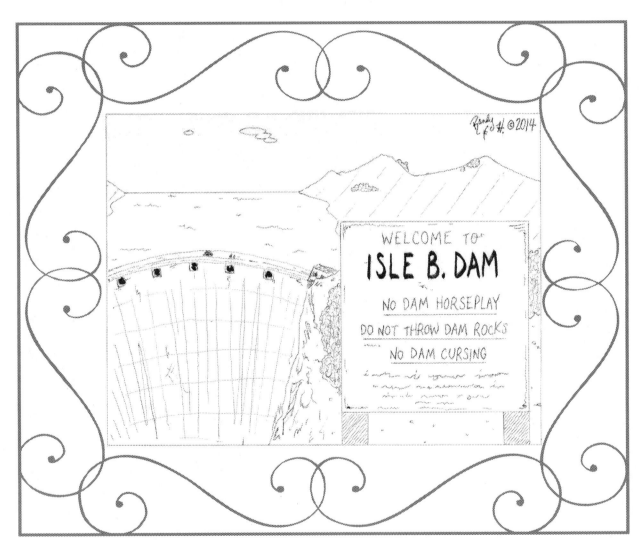

DEVIL-MAY-CARE HEADLINES

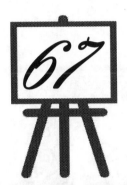

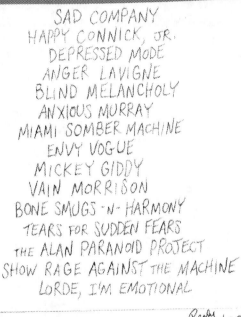

SAD COMPANY
HAPPY CONNICK, JR.
DEPRESSED MODE
ANGER LAVIGNE
BLIND MELANCHOLY
ANXIOUS MURRAY
MIAMI SOMBER MACHINE
ENVY VOGUE
MICKEY GIDDY
VAIN MORRISON
BONE SMUGS -N- HARMONY
TEARS FOR SUDDEN FEARS
THE ALAN PARANOID PROJECT
SHOW RAGE AGAINST THE MACHINE
LORDE, I'M EMOTIONAL

Randy K.H ©2014

MOODY JUKEBOXES

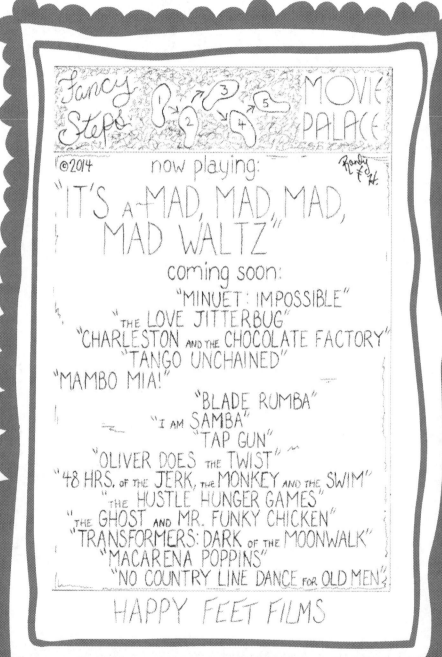

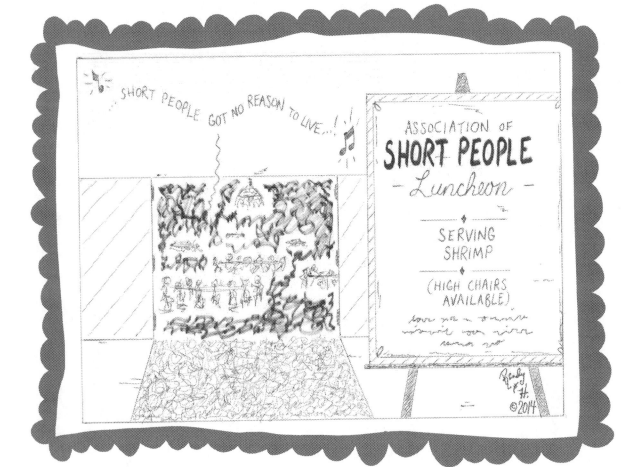

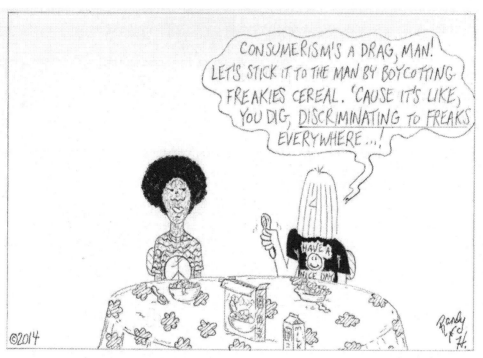

FLASHBACK: BREAKFAST TIME DURING THE 1970's

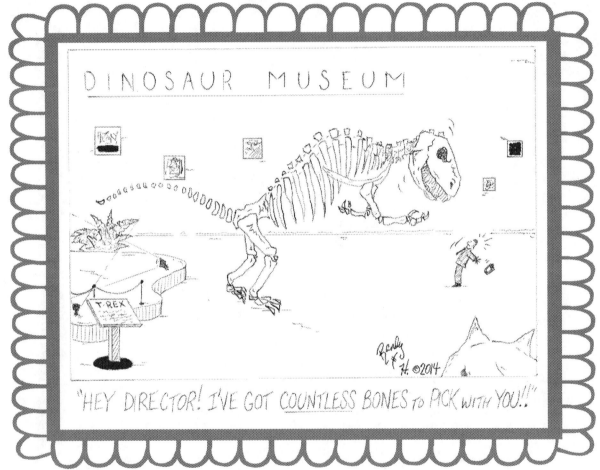

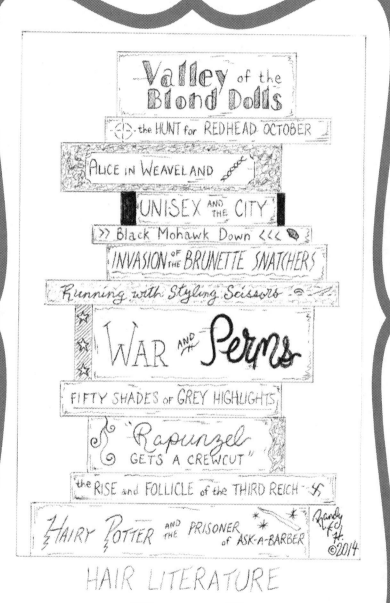

Valley of the Blond Dolls

the HUNT for REDHEAD OCTOBER

Alice in Weaveland

UNISEX AND THE CITY

>> Black Mohawk Down <<

INVASION OF THE BRUNETTE SNATCHERS

Running with Styling Scissors

WAR AND THE Perms

FIFTY SHADES OF GREY HIGHLIGHTS

"Rapunzel GETS A CREWCUT"

the RISE and FOLLICLE of the THIRD REICH

Hairy Potter AND THE PRISONER OF ASK-A-BARBER

Randy F.H. ©2014

HAIR LITERATURE

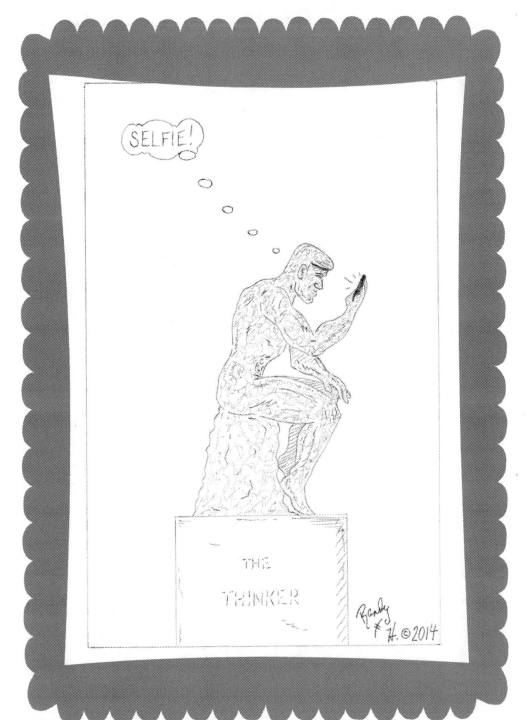

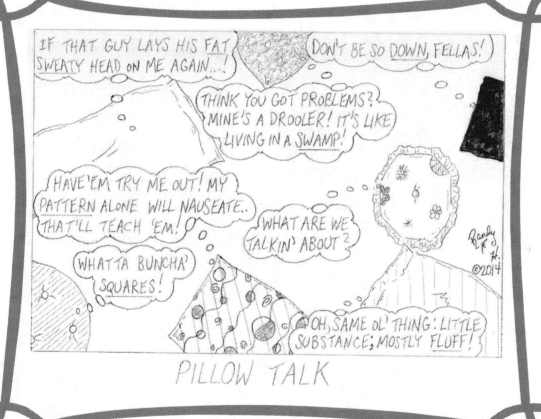

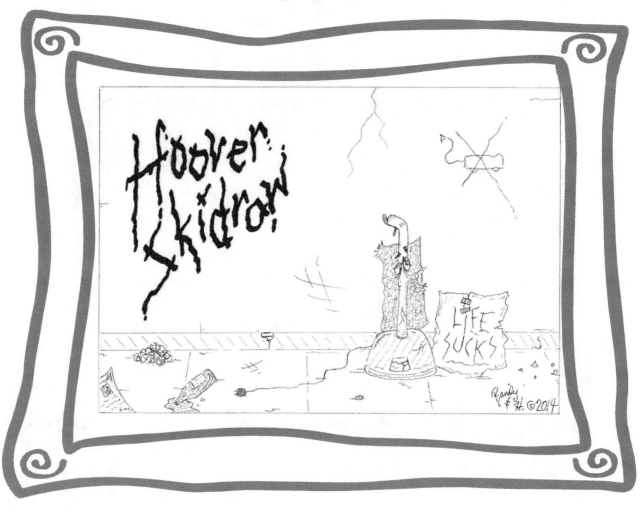

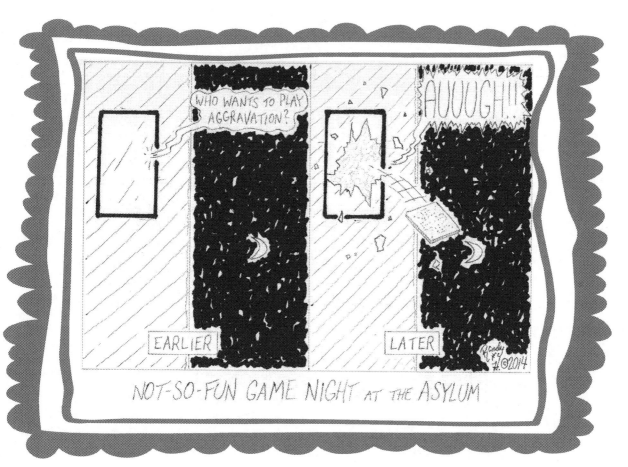

Randy H. ©2014

 ADAM
"HEADS UP, Y'ALL...IF UR NAKED, A FIG LEAF
WILL <u>NOT</u> STAY ON! WEIRD!!"

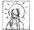 EVE
"WHA? A SNAKE GIVES US APPLE AND WARDROBE
MALFUNCTION IS <u>WEIRD</u> 2 U ??"

MOSES
"PARTED RED SEA TODAY. I DUNNO, KINDA
<u>FLASHY</u> 4 ME. GOING BOATING WOULDA'
WORKED TOO..."

NOAH
"DON'T WANNA HEAR ABOUT BOATS! STUCK
ON 1 WITH ANIMALS THAT STINK 2 HIGH
HEAVEN! EXCREMENT EVERYWHERE! IT'S A <u>ZOO</u>!!"

JUDAS
"NEW DIET SUCKS. SO CRAZY WITH HUNGER,
I COULD <u>BETRAY</u> SOMEONE >:("

J CHRIST
"ENOUGH! FROM 1 WHO <u>KNOWS</u>; GET OFF DA
FREAKIN' CROSS, GANG!! +"

BIBLE BLOGS

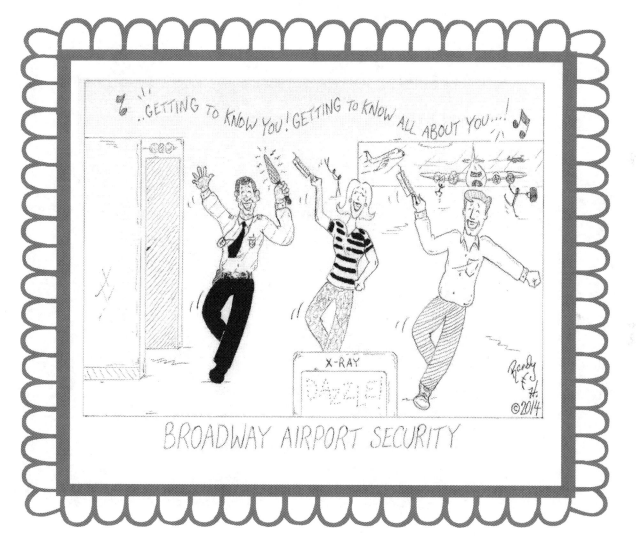

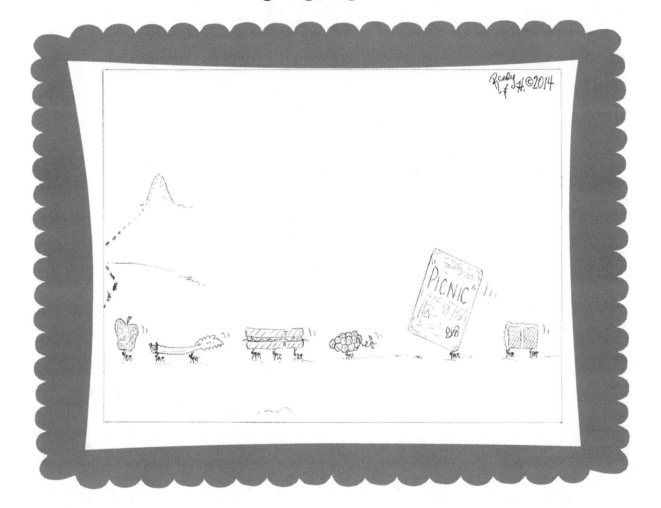

80

tuneful things CINEMA

now playing:

"TEENAGE MUTANT NINJA TUBAS"

coming soon:

"DRUM and DUMBER"
"ONE FLUTE OVER the CUCKOO'S NEST"
"GUITAR CHRISTIE LOVE!"
"the FRENCH HORN CONNECTION"
"HARMONICA POTTER and the HALF BLOOD PIANO"
"SAX and the CITY: the MOVIE"
"VIOLINS are BLUE"
"CLARINET with a CHANCE of MEATBALLS"
"CELLO, DOLLY!"
"the WORLD ACCORDING to HARP"
"BANJO UNCHAINED"
"the TAMBORINE of the SHREW"
"GREAT CYMBALS of FIRE!"
"FIDDLE of DREAMS"
"BEDTIME for BONGO"

Randy H. ©2014

MUSICAL INSTRUMENT MOTION PICTURES

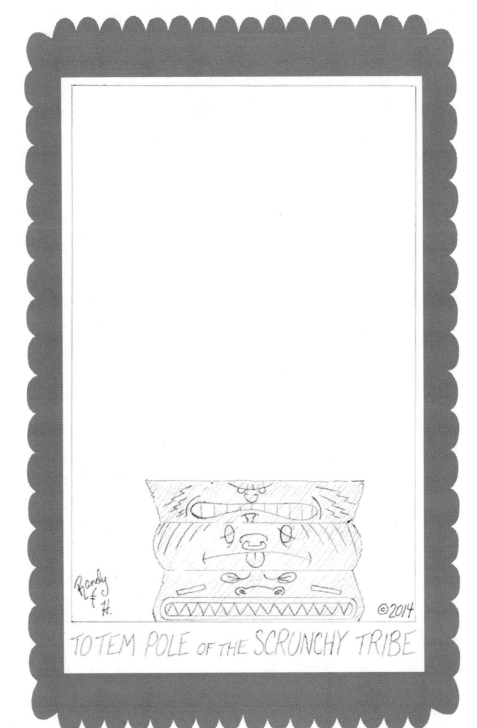

TOTEM POLE OF THE SCRUNCHY TRIBE

82

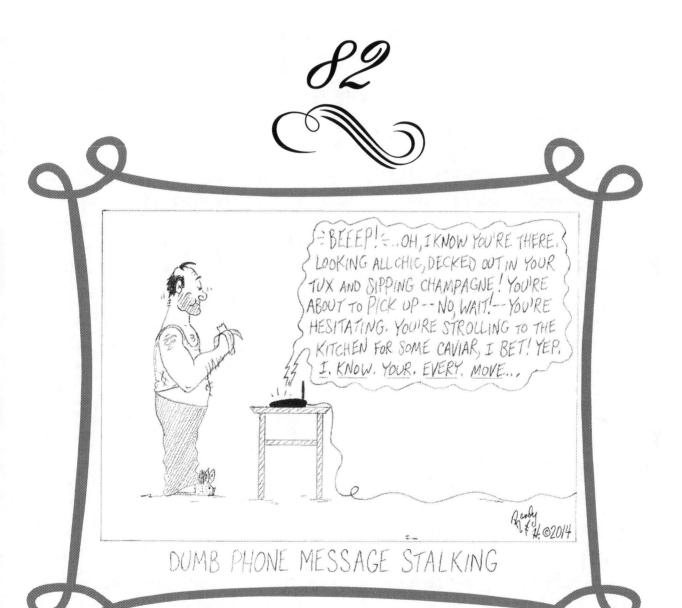

DUMB PHONE MESSAGE STALKING

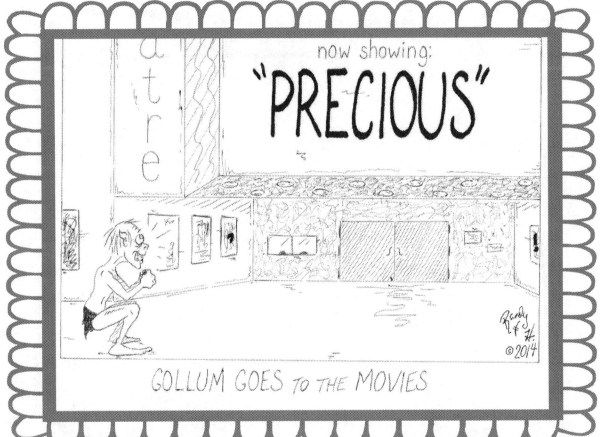

84

CURRY UNDERWOOD
FRANKIE GOES TO BOLLYWOOD
BUDDHA HOLLY
NEW DELHI KIDS ON THE BLOCK
STONE HINDU TEMPLE PILOTS
RED DOT CHILI PEPPERS
SARI McLACHLAN
THE HOLY ANIMALS
BACHMAN TURBAN OVERDRIVE
JOHNNY "SITAR" WATSON
SHERWANI CROW
OUTSOURCED-KAST
THE SACRED COWSILLS
WHITE SNAKE CHARMER
MONGOOSE AND COBRA STARSHIP

Randy Fox ©2014

INDIA JUKEBOXES

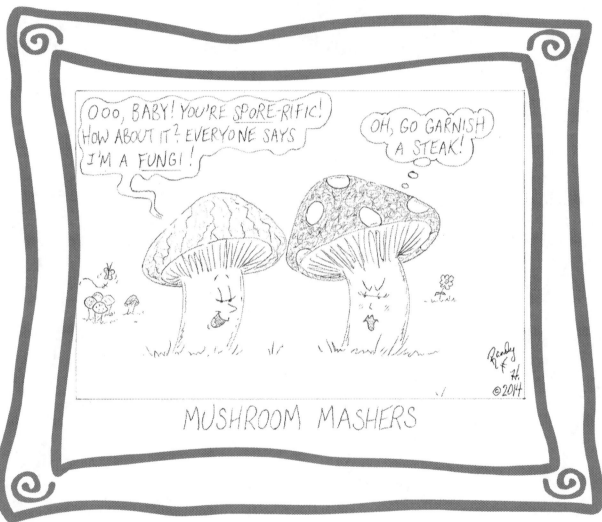

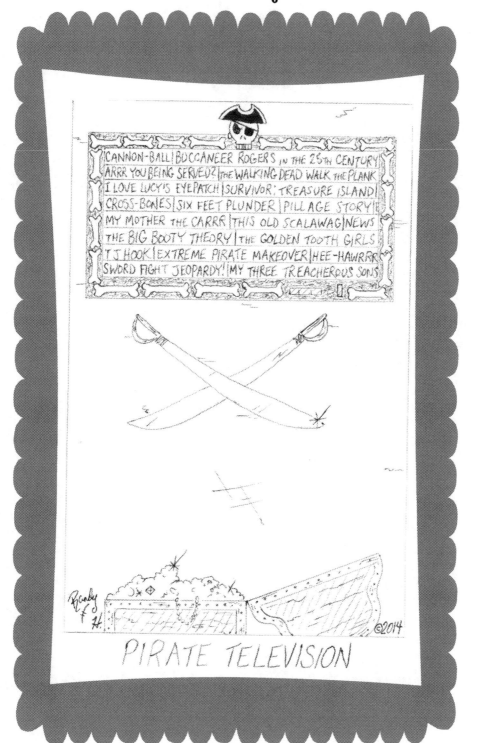

CANNON-BALL | BUCCANEER ROGERS IN THE 25TH CENTURY
ARRR YOU BEING SERVED? | THE WALKING DEAD WALK THE PLANK
I LOVE LUCY'S EYEPATCH | SURVIVOR: TREASURE ISLAND
CROSS-BONES | SIX FEET PLUNDER | PILLAGE STORY!
MY MOTHER THE CARRR | THIS OLD SCALAWAG | NEWS
THE BIG BOOTY THEORY | THE GOLDEN TOOTH GIRLS
T.J. HOOK | EXTREME PIRATE MAKEOVER | HEE-HAWRRR
SWORD FIGHT JEOPARDY! | MY THREE TREACHEROUS SONS

PIRATE TELEVISION

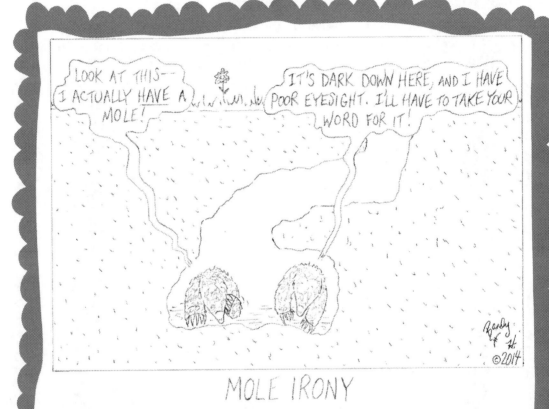

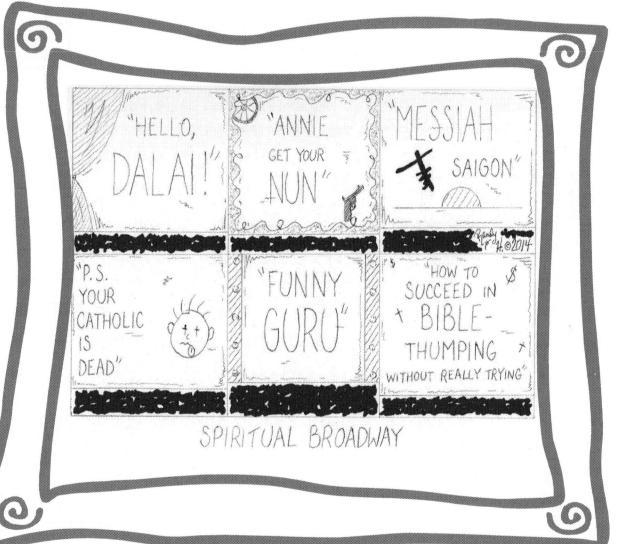

89

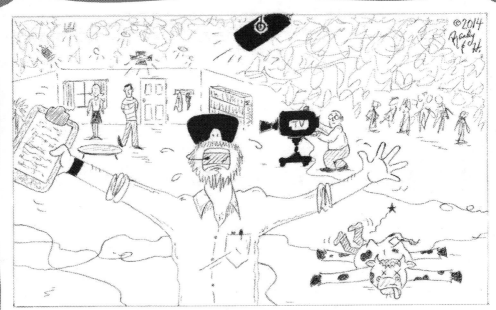

"WOULD SOMEONE PLEASE EXPLAIN TO THE PROPS DEPARTMENT THAT IN SKETCH COMEDY, 'DROPPING THE COW' DOESN'T LITERALLY MEAN DROPPING A REAL COW...!!"

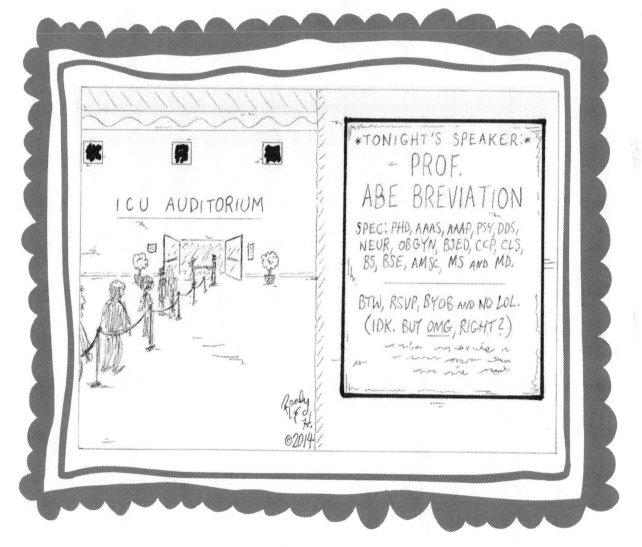

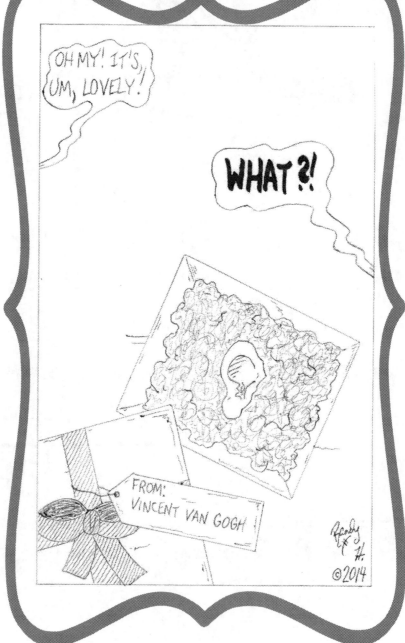

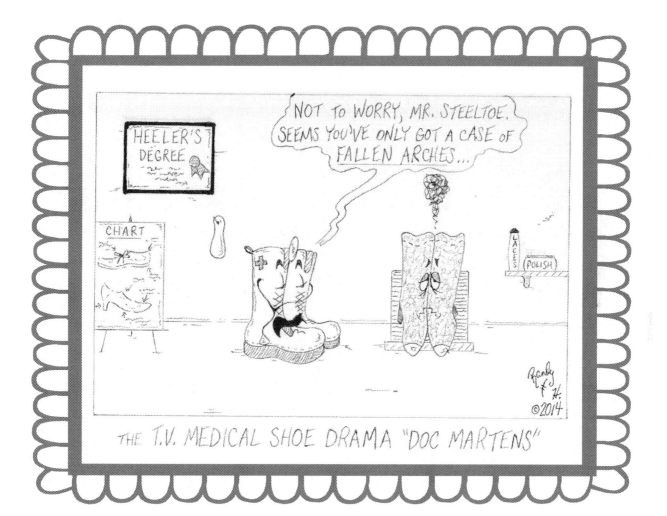

THE T.V. MEDICAL SHOE DRAMA "DOC MARTENS"

93

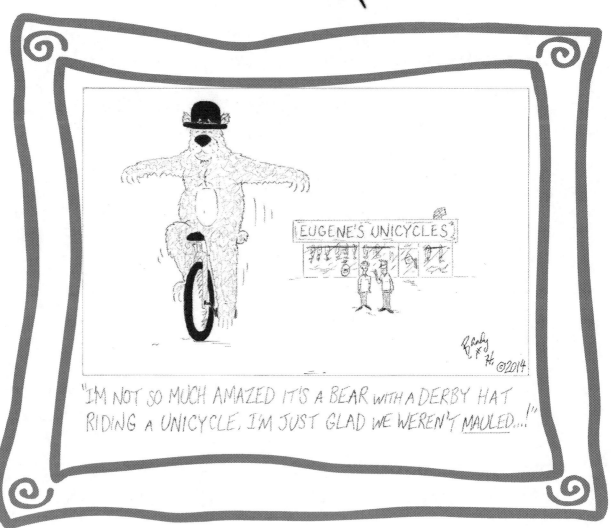

"I'M NOT SO MUCH AMAZED IT'S A BEAR WITH A DERBY HAT RIDING A UNICYCLE, I'M JUST GLAD WE WEREN'T MAULED...!"

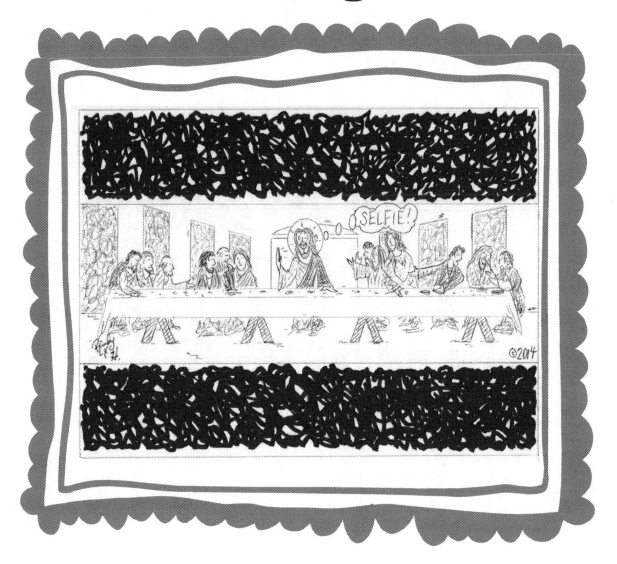

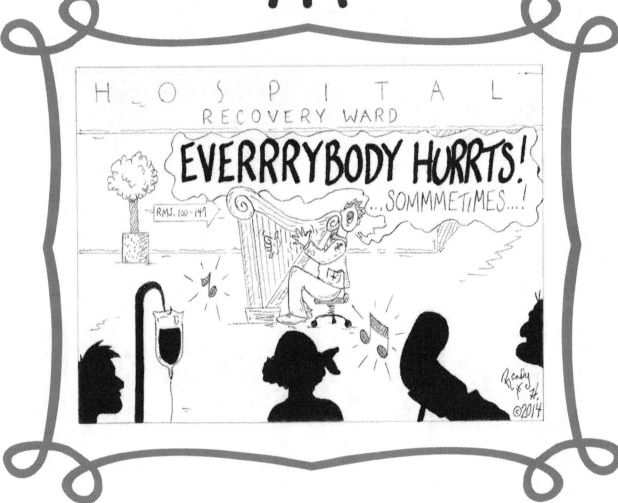

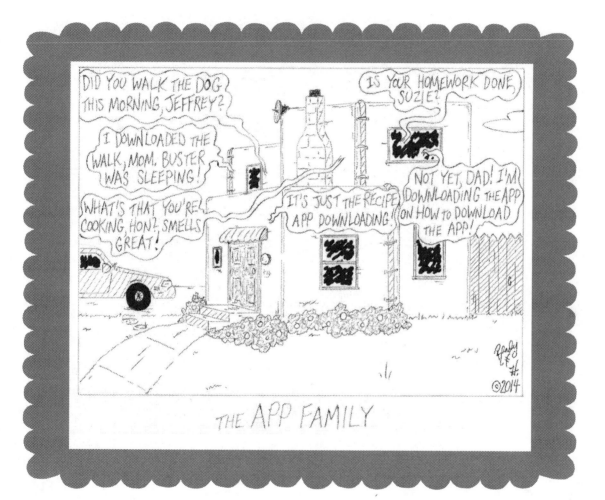

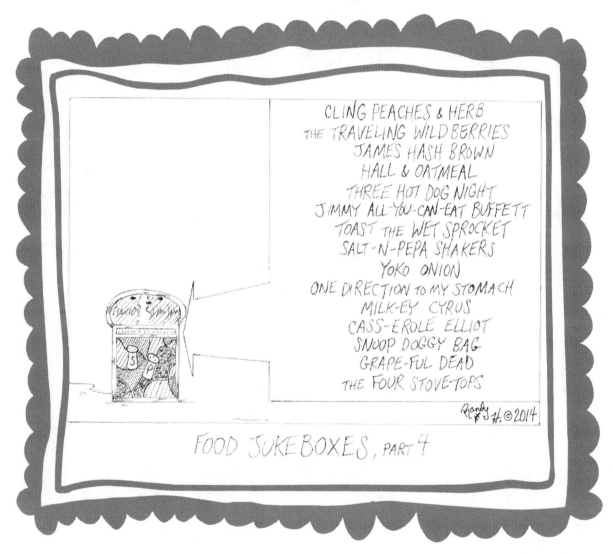

CLING PEACHES & HERB
THE TRAVELING WILD BERRIES
JAMES HASH BROWN
HALL & OATMEAL
THREE HOT DOG NIGHT
JIMMY ALL-YOU-CAN-EAT BUFFETT
TOAST THE WET SPROCKET
SALT-N-PEPA SHAKERS
YOKO ONION
ONE DIRECTION TO MY STOMACH
MILK-EY CYRUS
CASS-EROLE ELLIOT
SNOOP DOGGY BAG
GRAPE-FUL DEAD
THE FOUR STOVE-TOPS

FOOD JUKEBOXES, PART 4

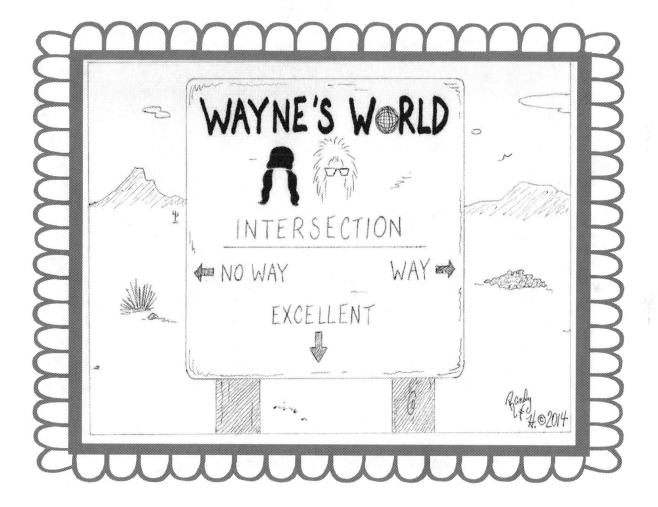

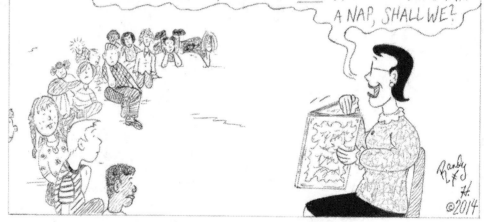

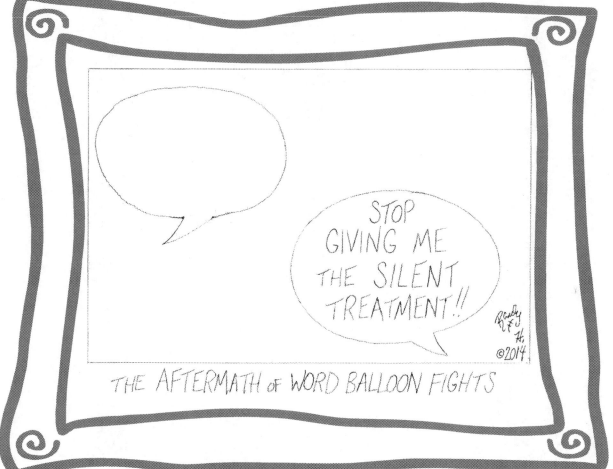

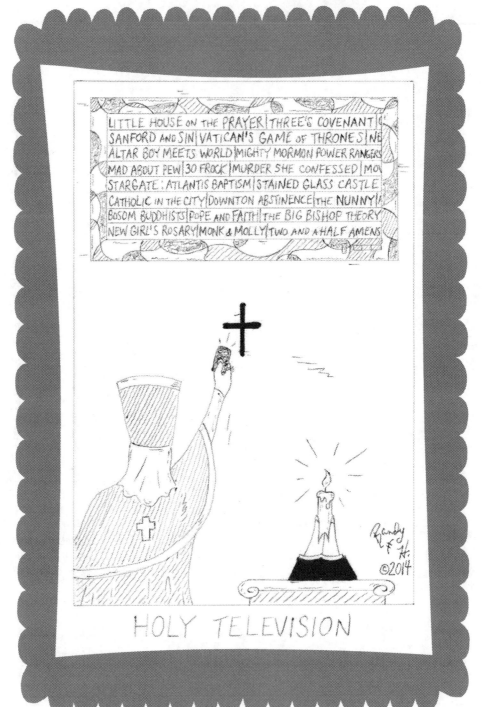

HOLY TELEVISION

BUSH LEAGUES

DASH of

ENTERTAINMENT flicks

now playing:

"GRAN-ULATED-SALT TORINO"

coming soon:

"BLACK PEPPER SWAN"
"THE OREGANO TRAIL of THE LONESOME PINE"
"PAPRIKA'S DELICATE CONDITION"
"CINNAMON KANE"
"THE ITALIAN HERBS JOB"
"PUMPKIN SPICE WORLD"
"GARLICIANS of THE GALAXY"
"THYME BANDITS"
"TANGO & MRS. DASH"
"THE GREAT WALDO CAJUN PEPPER"
"JURASSIC PARMESAN"
"THE ONION SALT FIELD"
"PARSLEY of THE CARIBBEAN"
"THE FABULOUS BACON-BIT BOYS"
"CROUTON FROM THE BLACK LAGOON"

©2014

"SEASONED" CINEMA

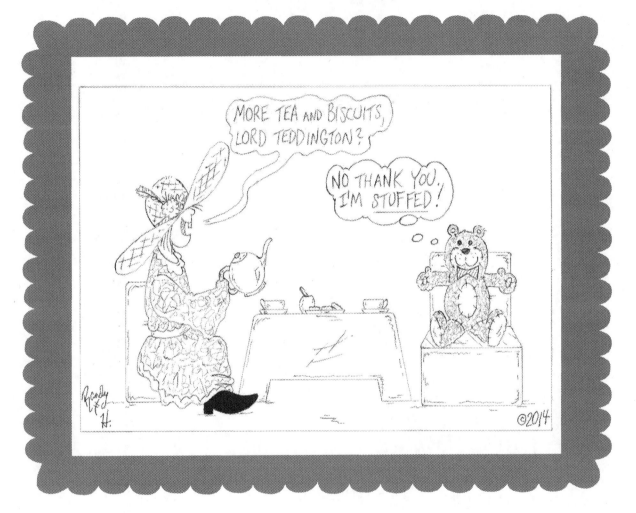

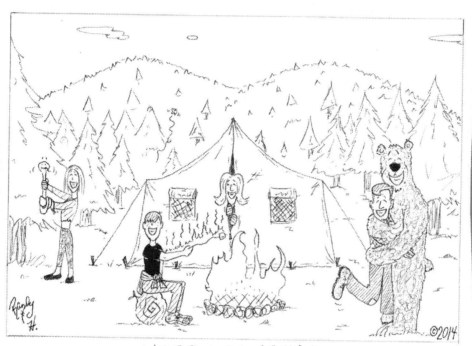

HAPPY CAMPERS

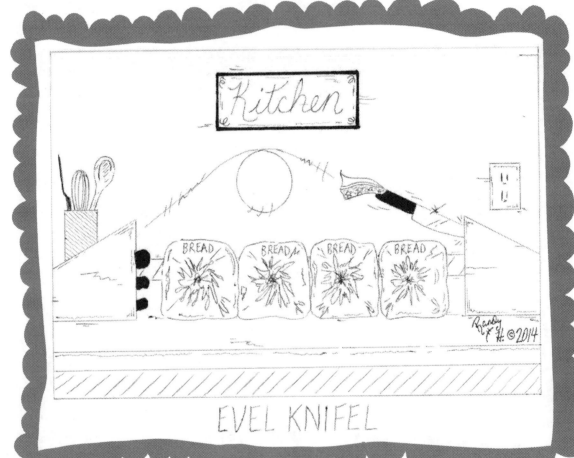

EVEL KNIFEL

LATE NIGHT'S "JIMMY CAMEL LIVE"

109

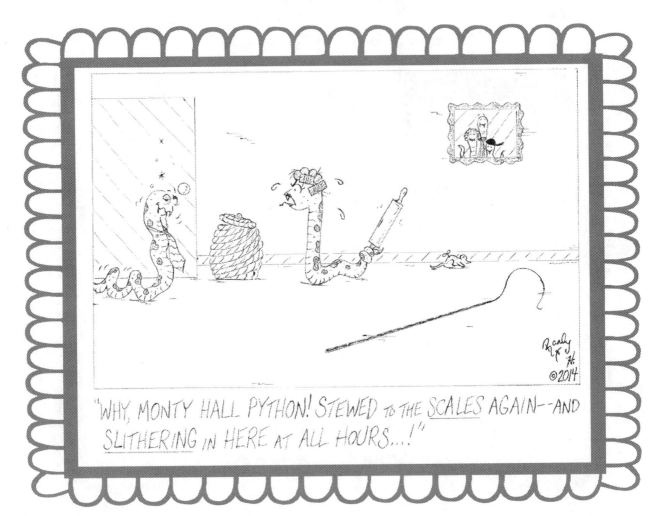

"WHY, MONTY HALL PYTHON! STEWED TO THE SCALES AGAIN--AND SLITHERING IN HERE AT ALL HOURS...!"

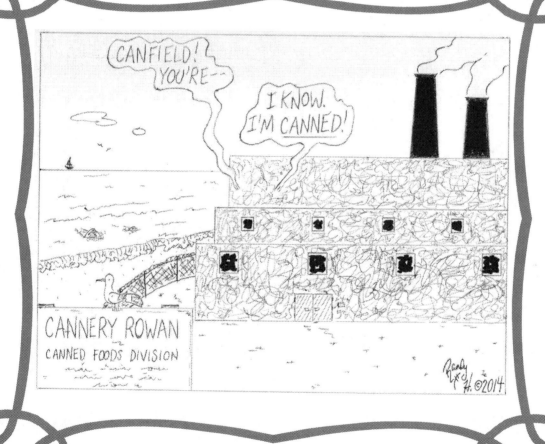

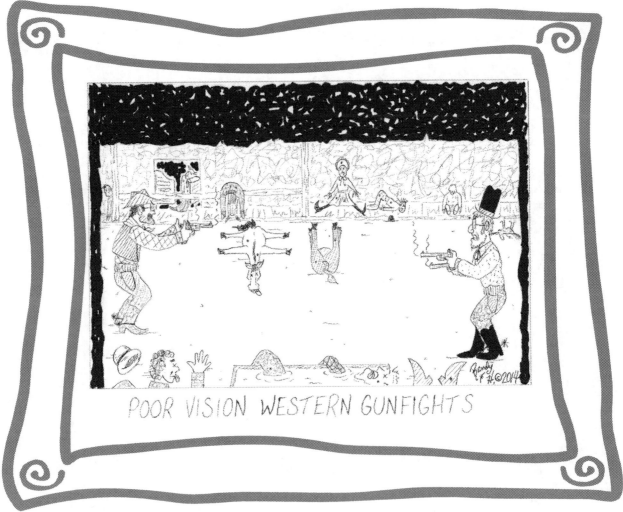

POOR VISION WESTERN GUNFIGHTS

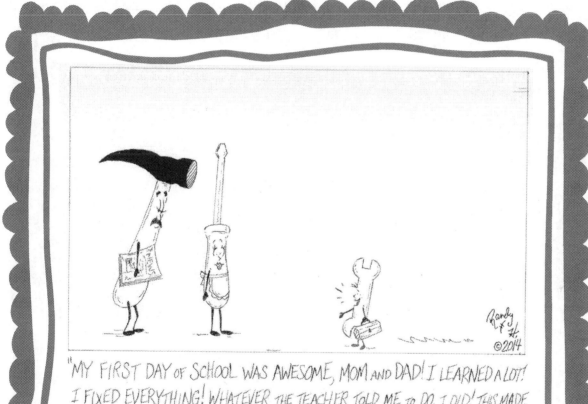

"MY FIRST DAY OF SCHOOL WAS AWESOME, MOM AND DAD! I LEARNED A LOT! I FIXED EVERYTHING! WHATEVER THE TEACHER TOLD ME TO DO, I DID! THIS MADE ME THE HAPPIEST TOOL IN THE WHOLE CLASS...!"

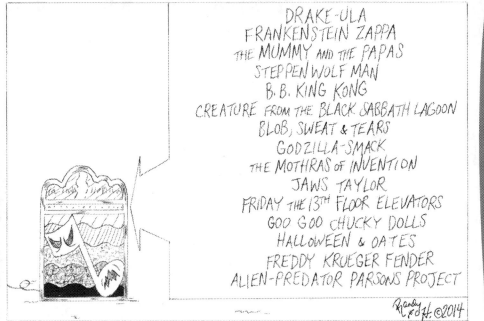

DRAKE-ULA
FRANKENSTEIN ZAPPA
THE MUMMY AND THE PAPAS
STEPPENWOLF MAN
B. B. KING KONG
CREATURE FROM THE BLACK SABBATH LAGOON
BLOB, SWEAT & TEARS
GODZILLA-SMACK
THE MOTHRAS OF INVENTION
JAWS TAYLOR
FRIDAY THE 13TH FLOOR ELEVATORS
GOO GOO CHUCKY DOLLS
HALLOWEEN & OATES
FREDDY KRUEGER FENDER
ALIEN-PREDATOR PARSONS PROJECT

Randy & J.H. ©2014

MONSTER JUKE BOXES

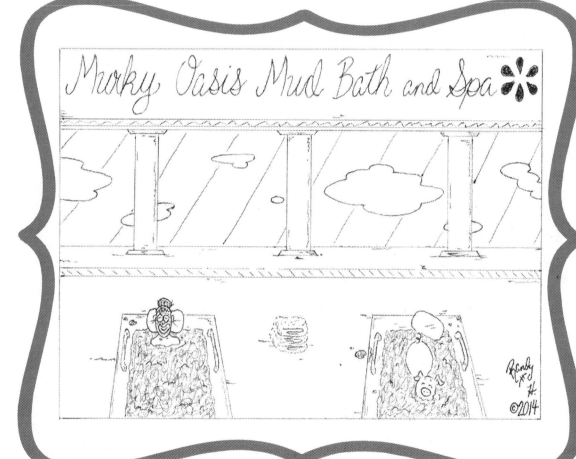

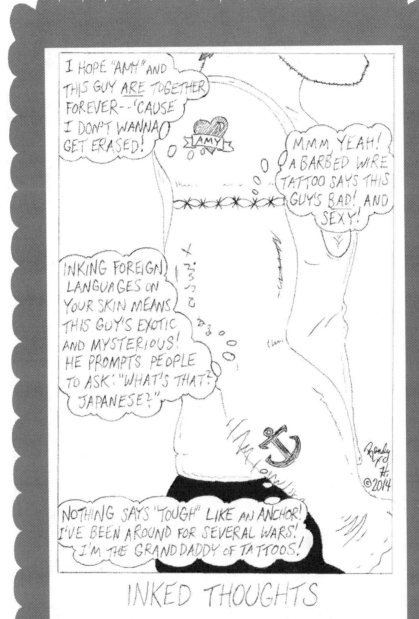

INKED THOUGHTS

"STAR WARS
ACTORS"

STARRING:

GEORGE LUCAS RAFT · De FORCE KELLEY · JEDI LAW
· MILLENNIUM FALCON JOVOVICH · LUKE SKYWALKER
WILSON · BILL DARTH VADER HADER · ANAKIN · MARGRET
· VIVIEN PRINCESS LEIA · C-3POMAR SHARIF · R2-D2
LEE ERMEY · WILLIAM H. SOLO MACY · RINGO DEATH
STARR · JIM CHEW-BACKUS · BEN OBI-WAN KENOBI
KINGSLEY · JOE LANDO CALRISSIAN · YODA BRYNN-
ER · JAR JAR BING CROSBY · AMIDALA ADAMS ·
EWOK McGREGOR · EVIL EMMA-PIRE STONE · PAUL
IMPERIAL WALKER · JABBA-HUTT LEMMON

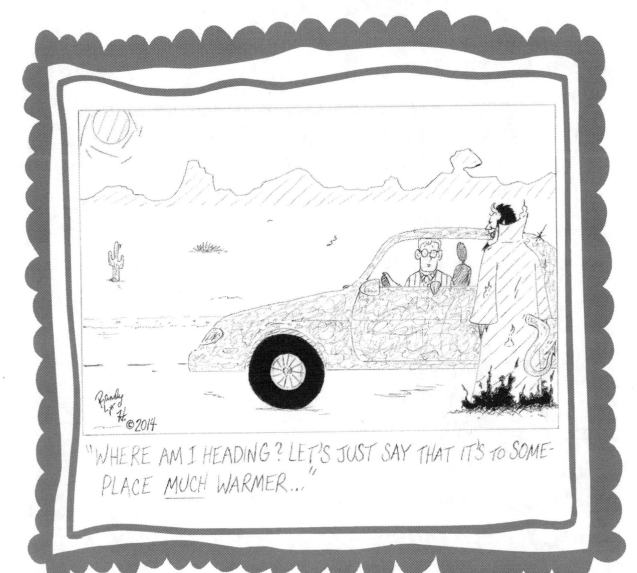

"WHERE AM I HEADING? LET'S JUST SAY THAT IT'S TO SOME-PLACE MUCH WARMER..."

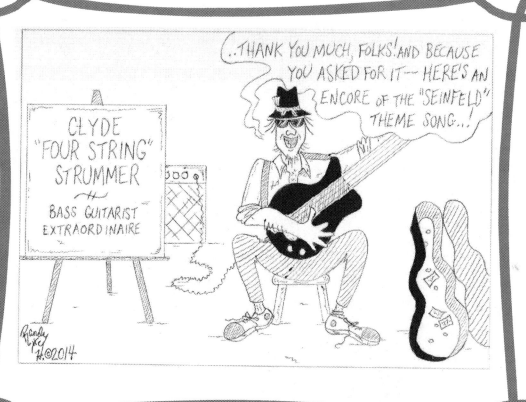

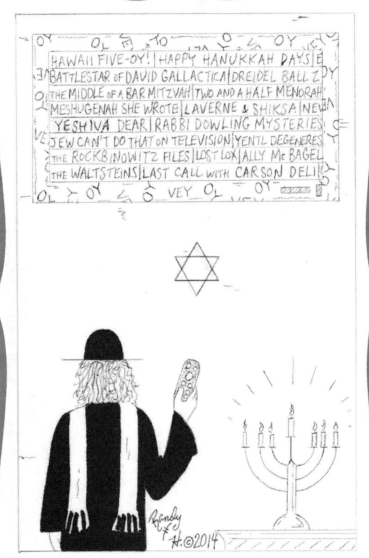

HAWAII FIVE-OY! | HAPPY HANUKKAH DAYS | E
BATTLESTAR of DAVID GALLACTICA | DREIDEL BALL Z
THE MIDDLE of A BAR MITZVAH | TWO AND A HALF MENORAH
MESHUGENAH SHE WROTE | LAVERNE & SHIKSA | NEW
YESHIVA DEAR | RABBI DOWLING MYSTERIES
JEW CAN'T DO THAT ON TELEVISION | YENTL DEGENERES
THE ROCKBINOWITZ FILES | LOST LOX | ALLY Mc BAGEL
THE WALTSTEINS | LAST CALL WITH CARSON DELI

JEWISH TELEVISION

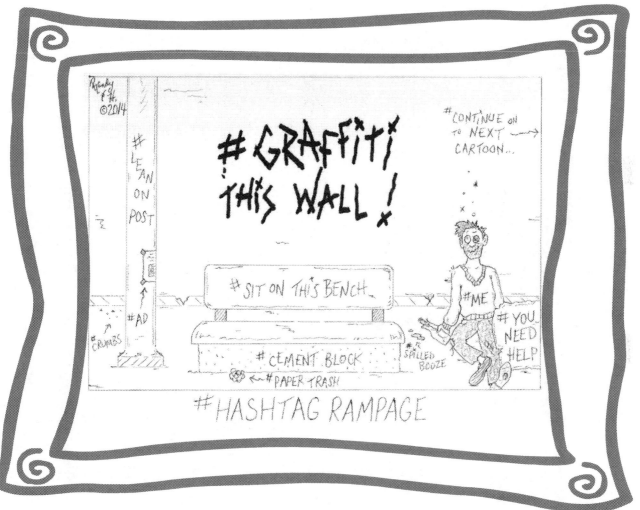

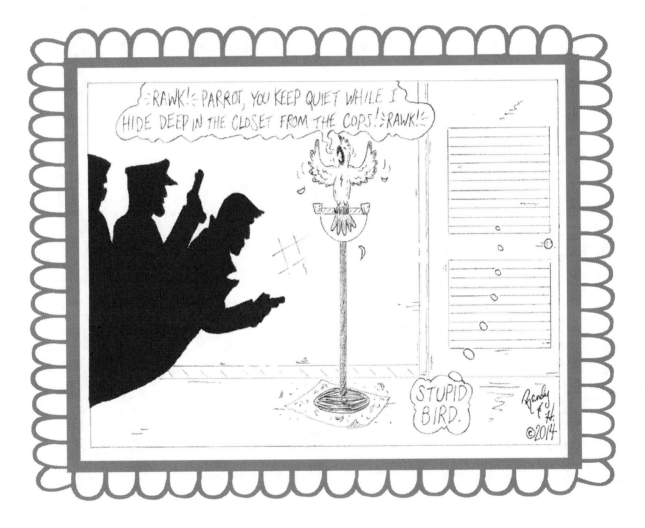

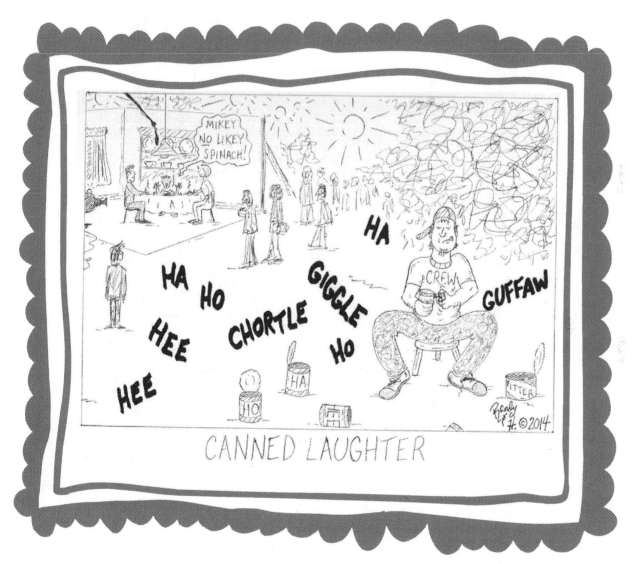

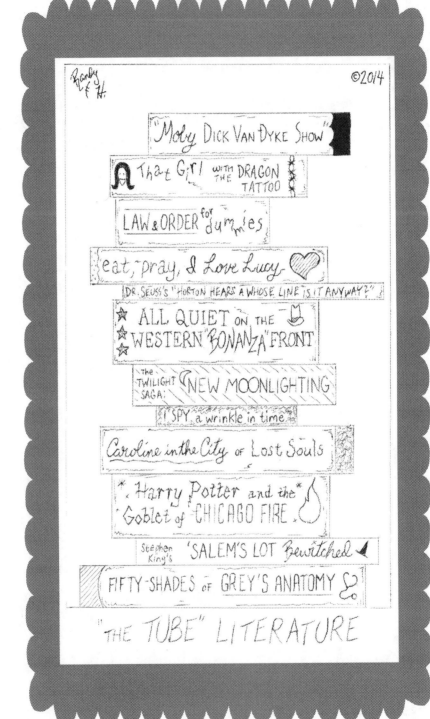

"THE TUBE" LITERATURE

124

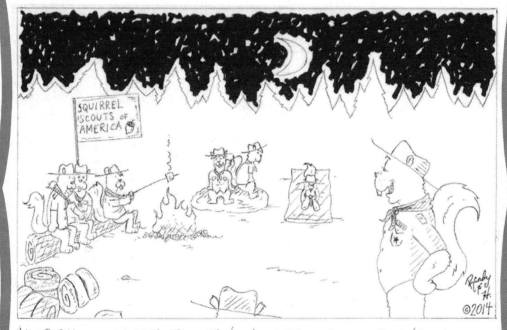

"AWRIGHT, MY LITTLE TROOPERS! IT'S TIME TO HIT THE SACK! 'CAUSE AT SONRISE, I WANT YOU ALL BRIGHT-EYED & BUSHY-TAILED...!"

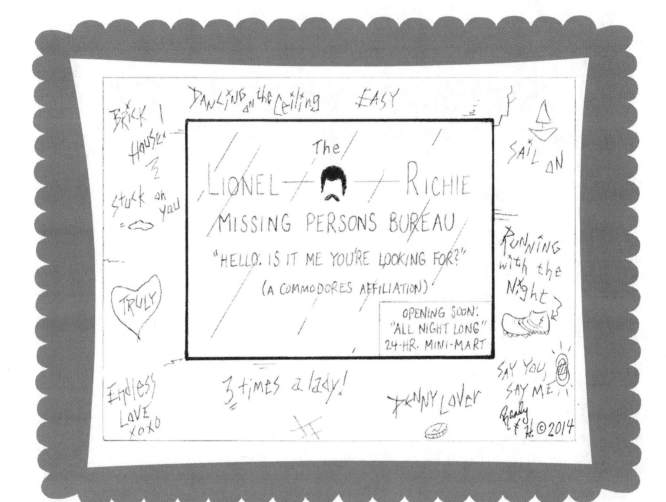

126

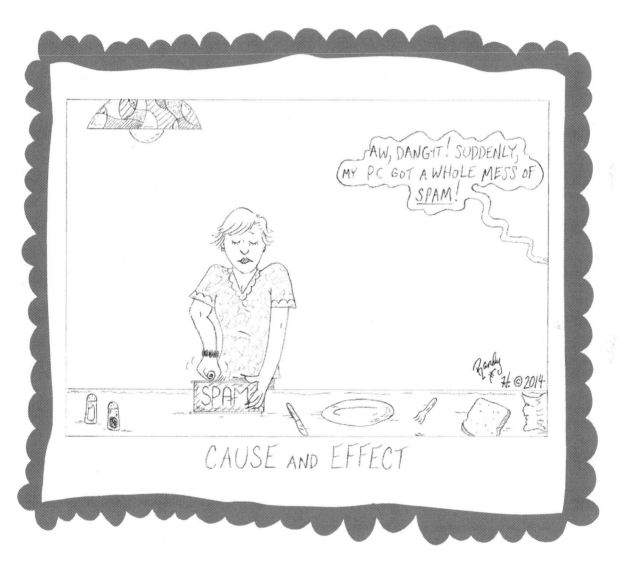

CAUSE AND EFFECT

127

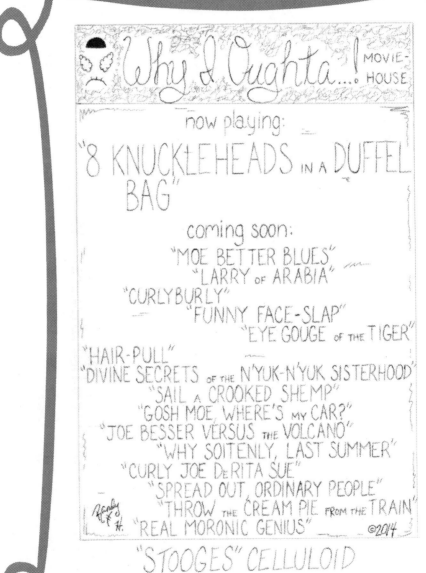

Why I Oughta...! MOVIE-HOUSE

now playing:

"8 KNUCKLEHEADS IN A DUFFEL BAG"

coming soon:

"MOE BETTER BLUES"
"LARRY OF ARABIA"
"CURLYBURLY"
"FUNNY FACE-SLAP"
"EYE GOUGE OF THE TIGER"

"HAIR-PULL"
"DIVINE SECRETS OF THE N'YUK-N'YUK SISTERHOOD"
"SAIL A CROOKED SHEMP"
"GOSH MOE, WHERE'S MY CAR?"
"JOE BESSER VERSUS THE VOLCANO"
"WHY SOITENLY, LAST SUMMER"
"CURLY JOE DeRITA SUE"
"SPREAD OUT, ORDINARY PEOPLE"
"THROW THE CREAM PIE FROM THE TRAIN"
"REAL MORONIC GENIUS"

©2014

"STOOGES" CELLULOID

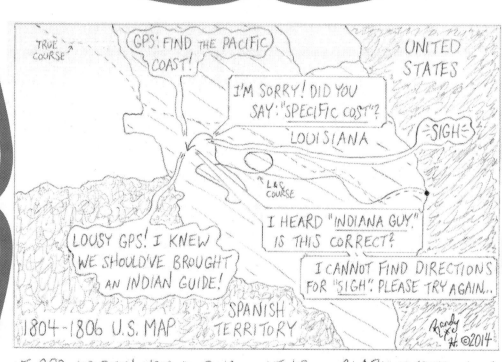

129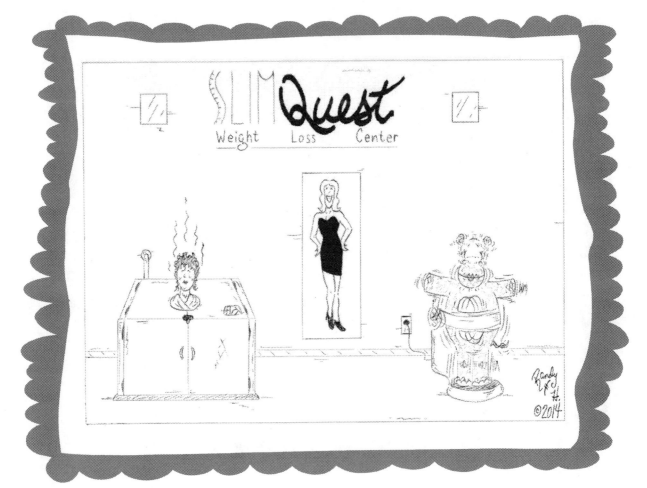

130

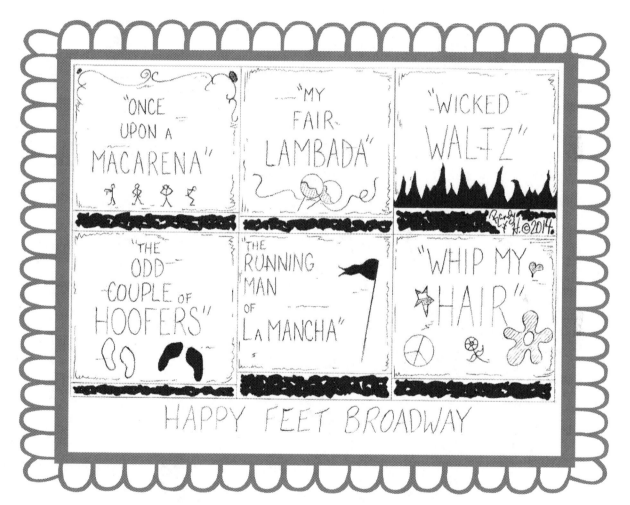

"ONCE UPON A MACARENA"

"MY FAIR LAMBADA"

"WICKED WALTZ"

"THE ODD COUPLE OF HOOFERS"

"THE RUNNING MAN OF La MANCHA"

"WHIP MY HAIR"

HAPPY FEET BROADWAY

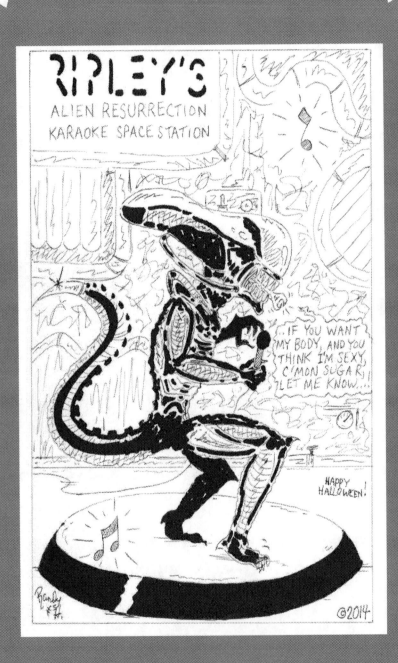

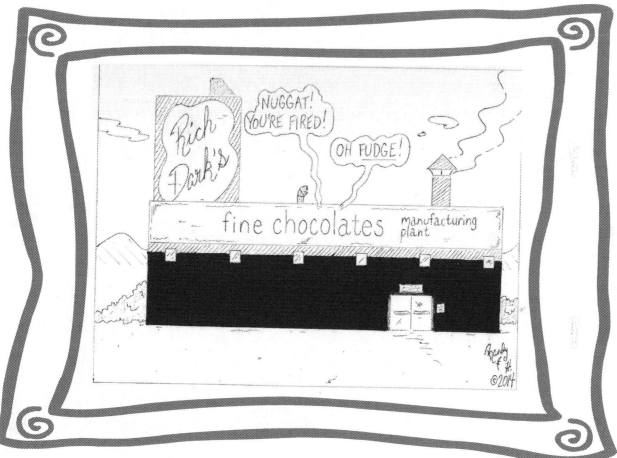

133

TEEN TELEVISION

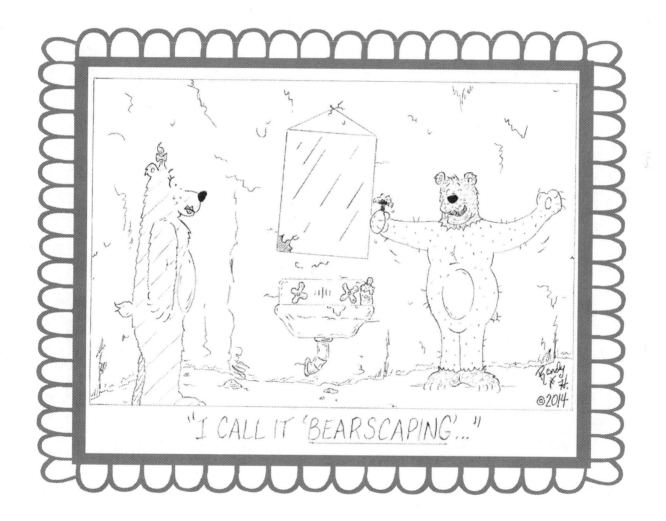

"I CALL IT 'BEARSCAPING'..."

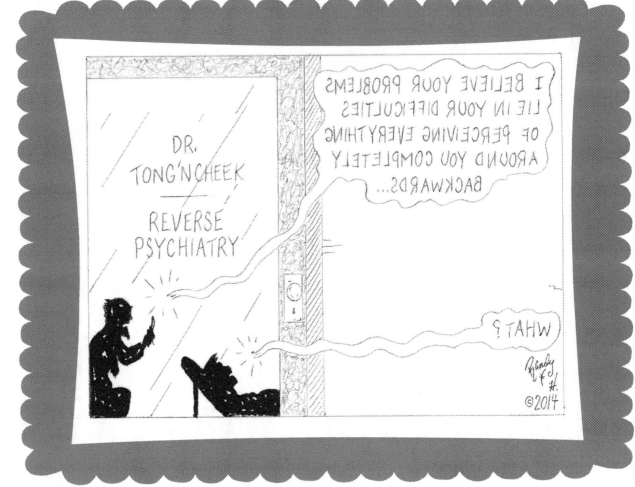

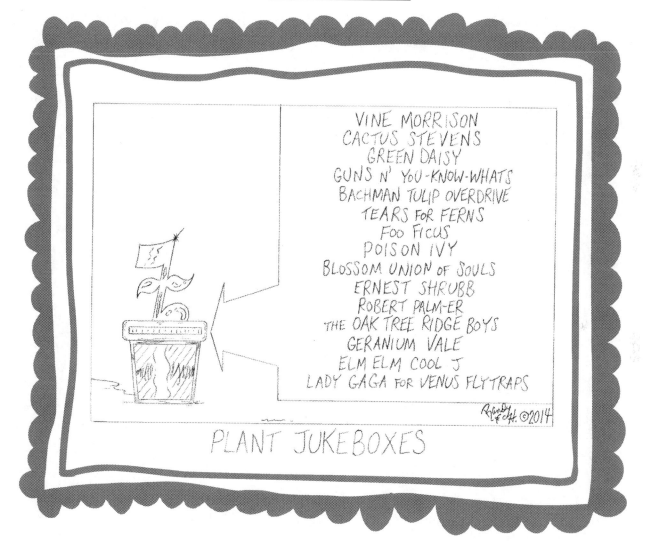

VINE MORRISON
CACTUS STEVENS
GREEN DAISY
GUNS N' YOU-KNOW-WHATS
BACHMAN TULIP OVERDRIVE
TEARS FOR FERNS
FOO FICUS
POISON IVY
BLOSSOM UNION OF SOULS
ERNEST SHRUBB
ROBERT PALM-ER
THE OAK TREE RIDGE BOYS
GERANIUM VALE
ELM ELM COOL J
LADY GAGA FOR VENUS FLYTRAPS

PLANT JUKEBOXES

137

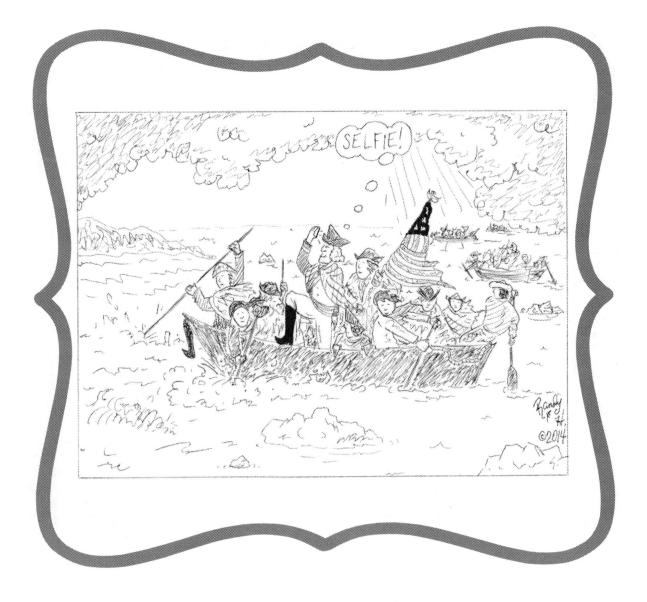

138

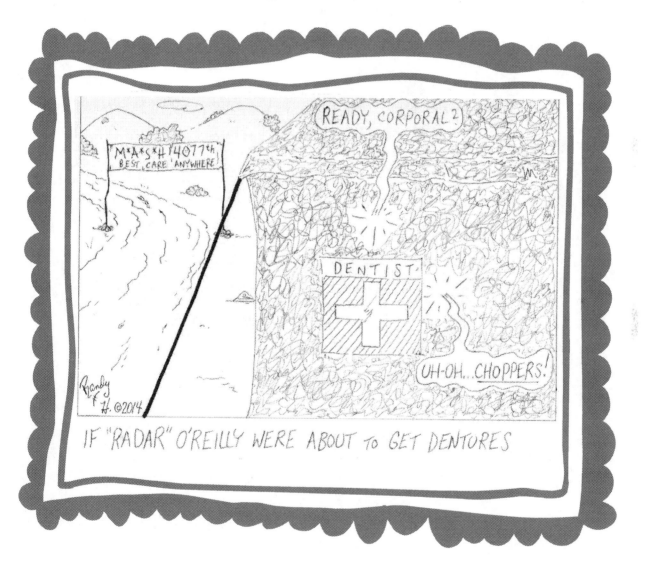

"BUG ACTORS"

STARRING:

DENNIS GRASSHOPPER · JAMES SPIDER · QUEEN
BEE LATIFAH · CLINT EARWIG · ROACH MORANIS ·
JACK BLACK-WIDOW · KAT-ERPILLAR DENNINGS ·
FLY-RONE POWER · WARREN BEETLE · LANA
LADYBUG TURNER · HARVEY FIREFLY-STEIN ·
YELLOWJACKET NICHOLSON · CENTI-PETER
SELLERS · MORGAN FREEMANTIS · ANT HATH-
AWAY · STING MARTIN · TARANTULA REID · RED
ANT BUTTONS · JOHN SAVAGE MOSQUITO ·
BUTTERFLY DAVIS · JOAN CREEPYCRAWLEY-
FORD · PEST PARKER · KATYDID HUDSON

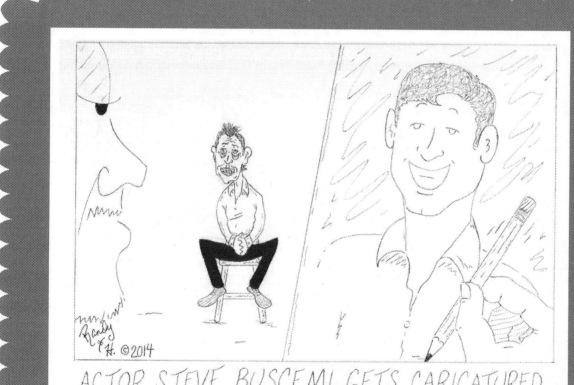

141

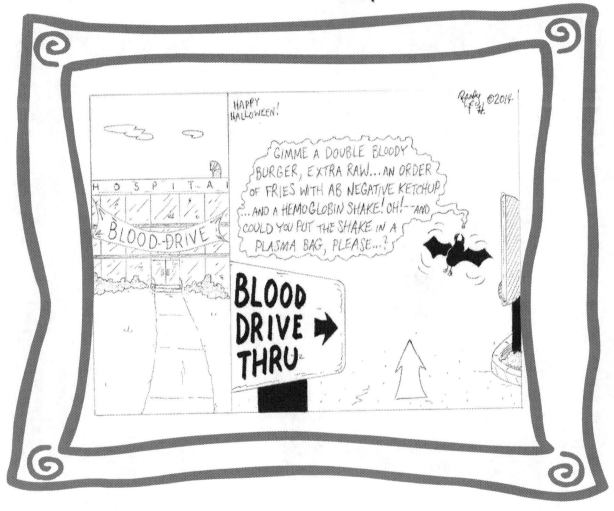

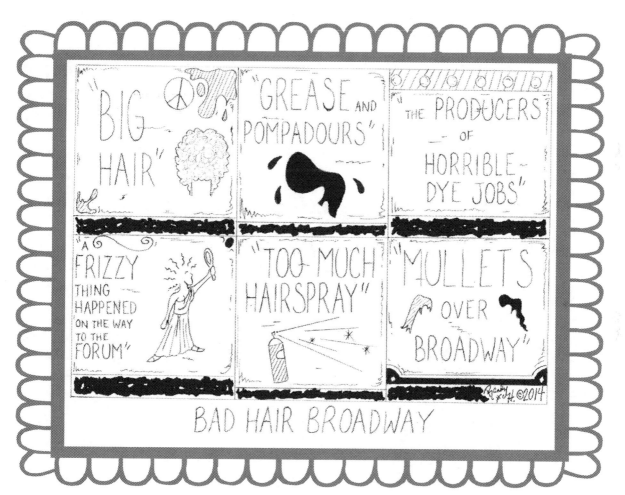

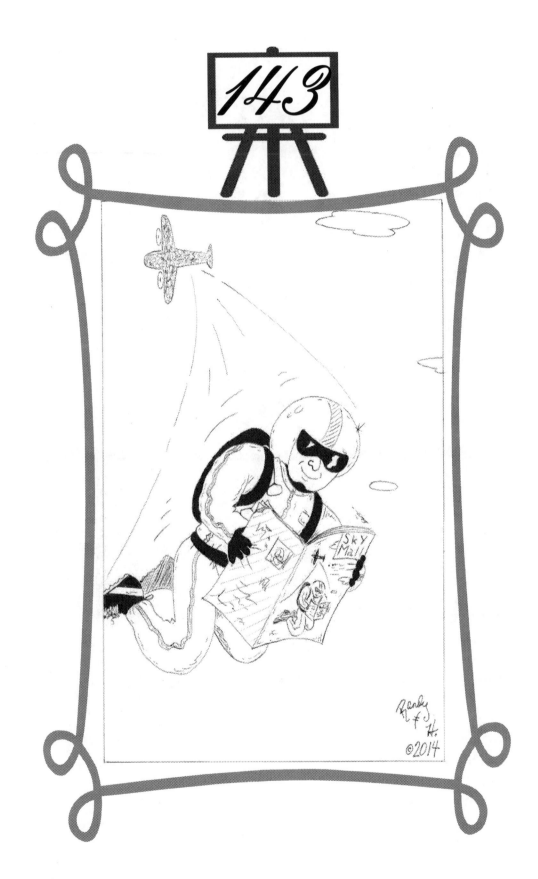

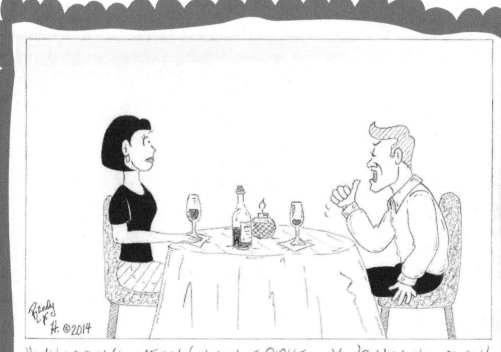

"WHADDAYA MEAN, 'I'M NOT RIGHT FOR YOU'? HEY, I'M A CATCH! OVER 20,000 LIKES ON FACEBOOK BACKS THAT UP...!!"

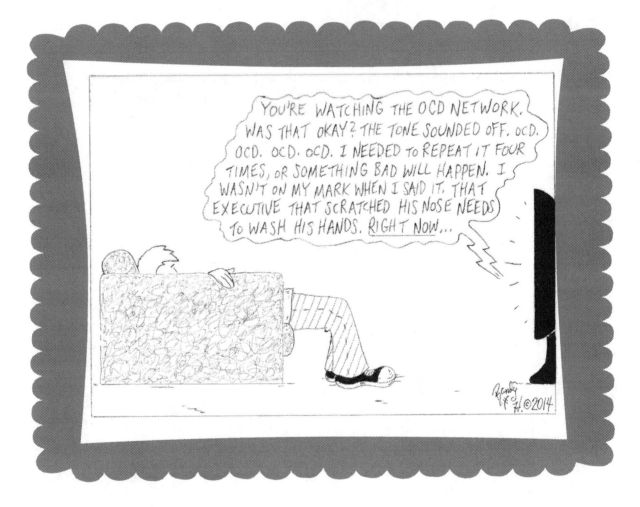

146

SILVER TRAIL SPOONS | THE NEW ADVENTURES of SLOW CHRISTINE
ONCE UPON A SLIME | SHELL'S KITCHEN | SLUGGY HOLLOW | A
MY MOTHER THE ESCARGO | ANTENNAED FRIENDS | NE
SNAILFELD | WHO DO YOU THINK YOU ARE, EATING MY GARDEN?
CRAWLING CRIMINAL MINDS | SNAIL BAIT JEOPARDY!
SLUGS of ANARCHY | SAVED BY THE SHELL | MOVIE : O
HAWAII FIVE ESCARG-O | THE BIGGEST LOSER of SPEED
ADVENTURE SLIME | SALT TREK : DEEP SNAIL NINE

Randy H. ©2014

SNAIL TELEVISION

147

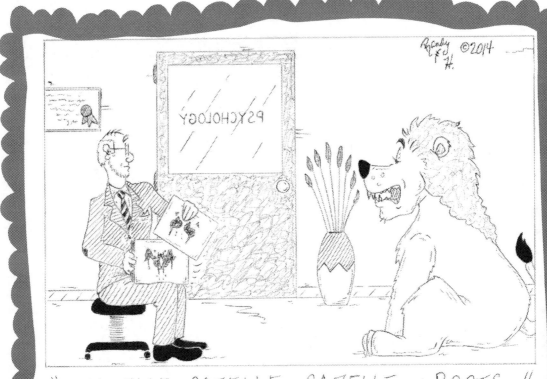

"...GAZELLE...GAZELLE...GAZELLE in BOOTS..."

148

Down Under theatre

now playing:

Refundly F. H. © 2014

"X-MEN: G'DAYS of FUTURE PAST"

coming soon:

"JAILHOUSE CROC"
"COOL HAND LUKE HAS NO WORRIES, MATE"
"CITIZEN KANGAROO"
"SYDNEY & NANCY"
"A WALKABOUT TO REMEMBER"
"KOALA MINER'S DAUGHTER"
"OUTBACK TO THE FUTURE"
"WALLABY STREET"
"WOM-BATMAN"
"MELBOURNE YESTERDAY"
"THE HUNGER GAMES PUTS A SHRIMP ON THE BARBIE"
"ABORIGINAL SIN"
"THE EMU STRIKES BACK"
"V FOR VEGEMITE VENDETTA"
"NATIONAL TREASURE: PAUL HOGAN"
"LAND DOWN UNDER THE TUSCAN SUN"

AUSTRALIAN FLICKS

149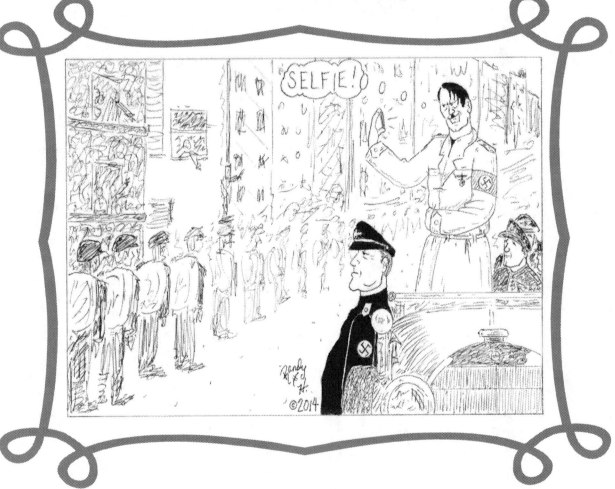

150

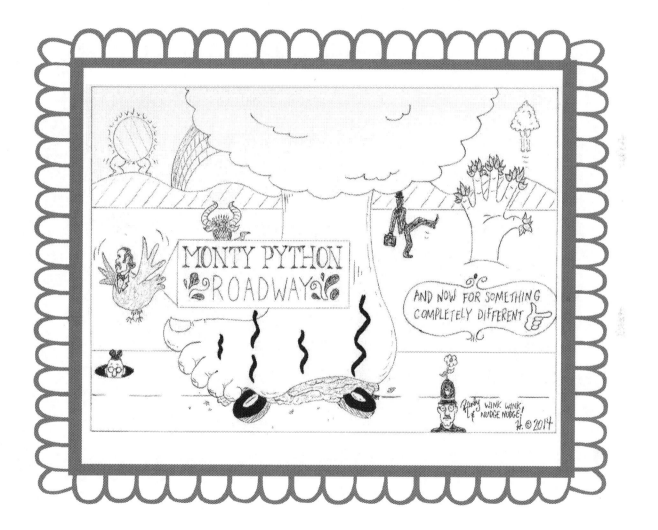

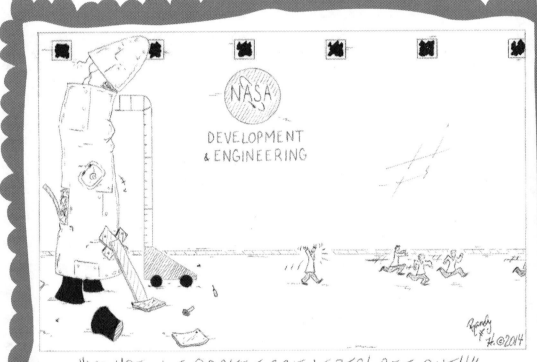

"YOU'RE NOT ROCKET SCIENTISTS! GET OUT!!"

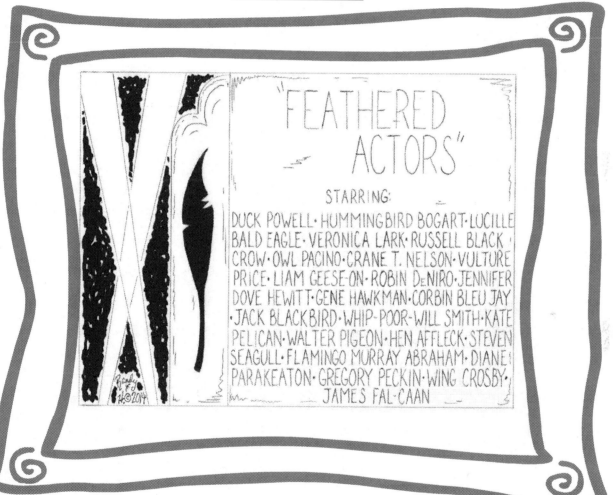

"FEATHERED ACTORS"

STARRING:

DUCK POWELL • HUMMINGBIRD BOGART • LUCILLE BALD EAGLE • VERONICA LARK • RUSSELL BLACK CROW • OWL PACINO • CRANE T. NELSON • VULTURE PRICE • LIAM GEESE-ON • ROBIN DeNIRO • JENNIFER DOVE HEWITT • GENE HAWKMAN • CORBIN BLEU JAY • JACK BLACKBIRD • WHIP-POOR-WILL SMITH • KATE PELICAN • WALTER PIGEON • HEN AFFLECK • STEVEN SEAGULL • FLAMINGO MURRAY ABRAHAM • DIANE PARAKEATON • GREGORY PECKIN • WING CROSBY • JAMES FAL-CAAN

153

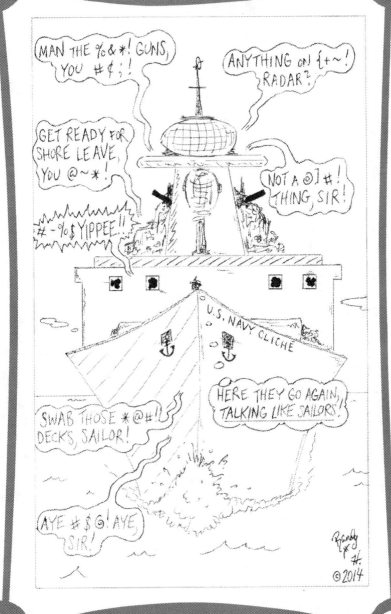

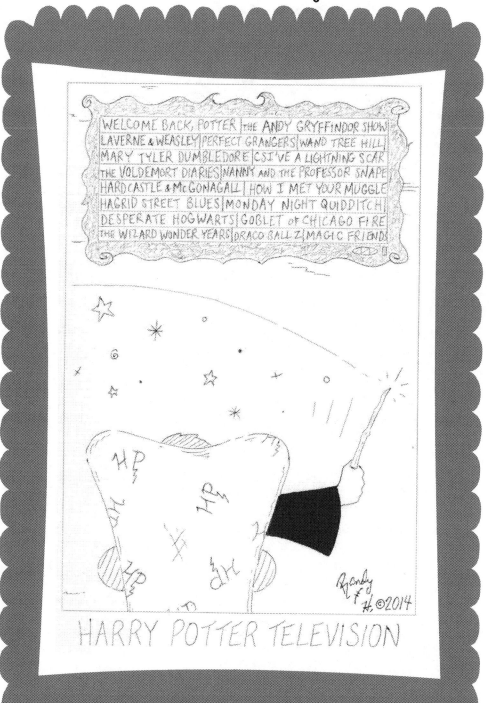

HARRY POTTER TELEVISION

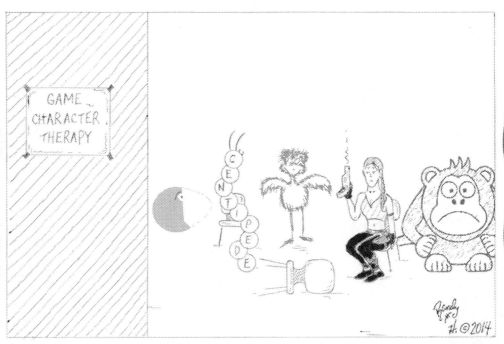

"OF COURSE, I'M UPSET! I'M AN ANGRY BIRD, YOU IDIOTS!!"

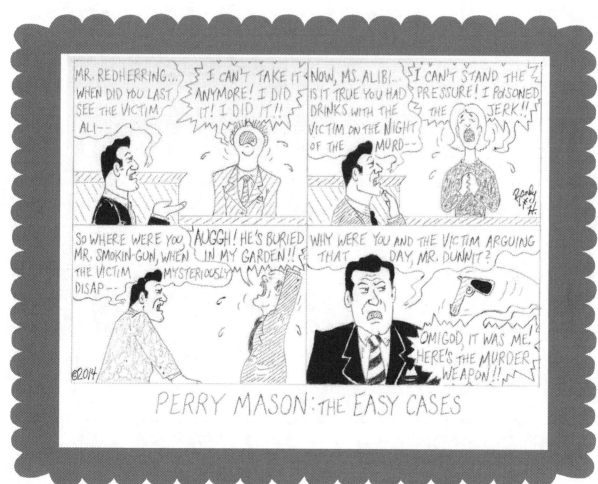

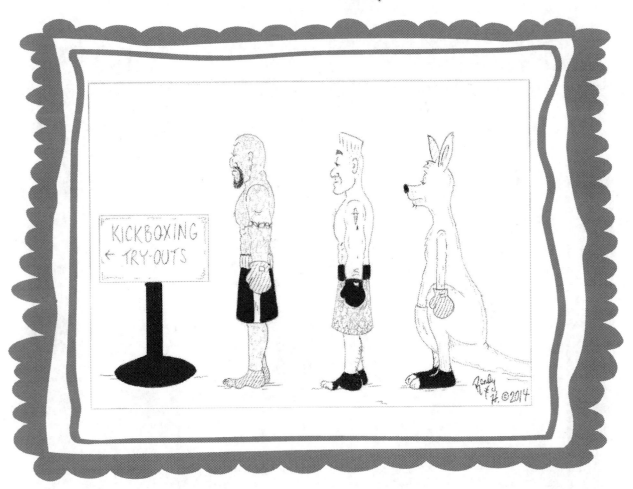

158

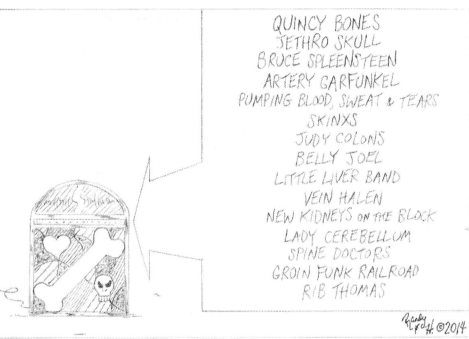

QUINCY BONES
JETHRO SKULL
BRUCE SPLEENSTEEN
ARTERY GARFUNKEL
PUMPING BLOOD, SWEAT & TEARS
SKINXS
JUDY COLONS
BELLY JOEL
LITTLE LIVER BAND
VEIN HALEN
NEW KIDNEYS ON THE BLOCK
LADY CEREBELLUM
SPINE DOCTORS
GROIN FUNK RAILROAD
RIB THOMAS

ANATOMY JUKEBOXES

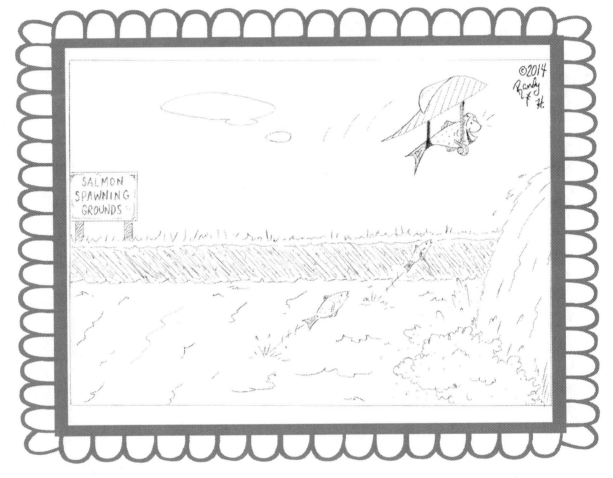

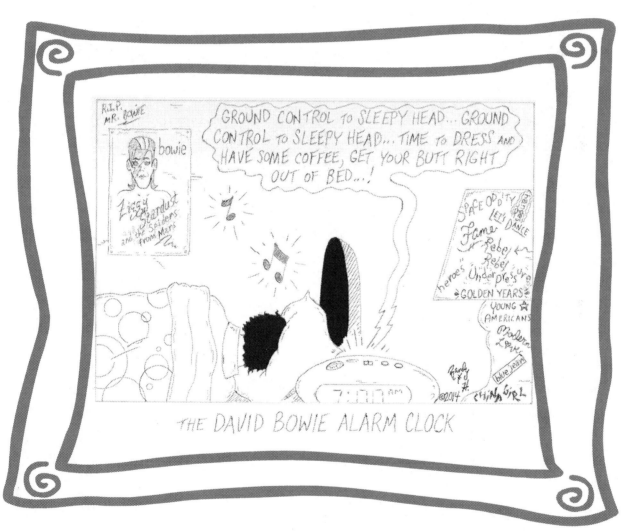

THE DAVID BOWIE ALARM CLOCK

161

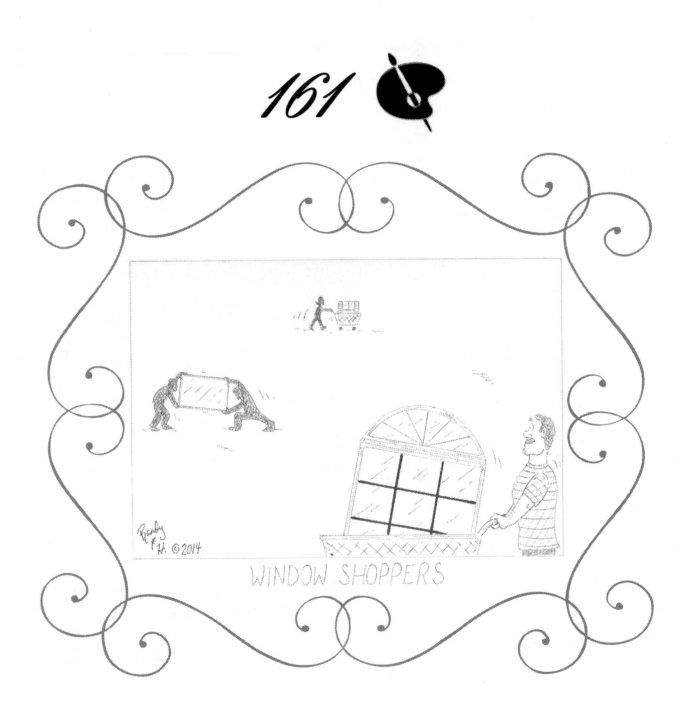

WINDOW SHOPPERS

162

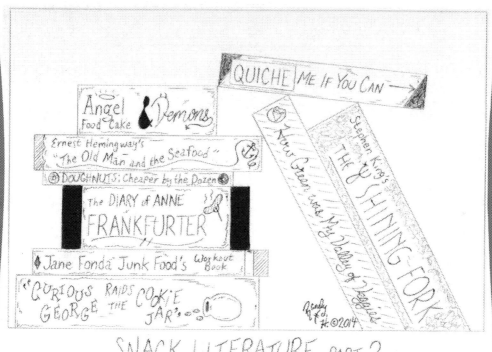

QUICHE ME IF YOU CAN →

Angel Food Cake & Demons

Ernest Hemingway's "The Old Man and the Seafood"

DOUGHNUTS: Cheaper by the Dozen

The DIARY of ANNE FRANKFURTER

Jane Fonda Junk Food's Workout Book

"CURIOUS GEORGE RAIDS THE COOKIE JAR"

Never Green with My Valley of Veggies

Stephen King's THE SHINING FORK

Brady H. ©2014

SNACK LITERATURE, PART 2

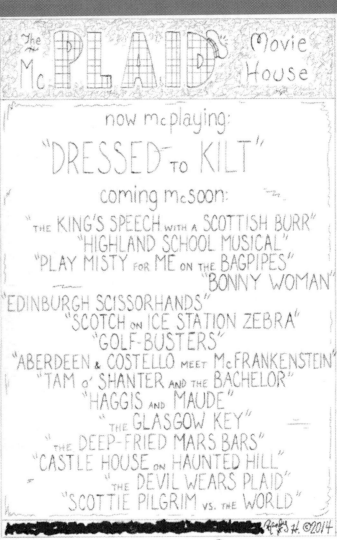

The Mc**PLAID** Movie House

now mcplaying:
"DRESSED TO KILT"

coming mcsoon:

"THE KING'S SPEECH WITH A SCOTTISH BURR"
"HIGHLAND SCHOOL MUSICAL"
"PLAY MISTY FOR ME ON THE BAGPIPES"
"BONNY WOMAN"

"EDINBURGH SCISSORHANDS"
"SCOTCH ON ICE STATION ZEBRA"
"GOLF-BUSTERS"
"ABERDEEN & COSTELLO MEET McFRANKENSTEIN"
"TAM o' SHANTER AND THE BACHELOR"
"HAGGIS AND MAUDE"
"THE GLASGOW KEY"
"THE DEEP-FRIED MARS BARS"
"CASTLE HOUSE ON HAUNTED HILL"
"THE DEVIL WEARS PLAID"
"SCOTTIE PILGRIM VS. THE WORLD"

©2014

SCOTTISH McREELS

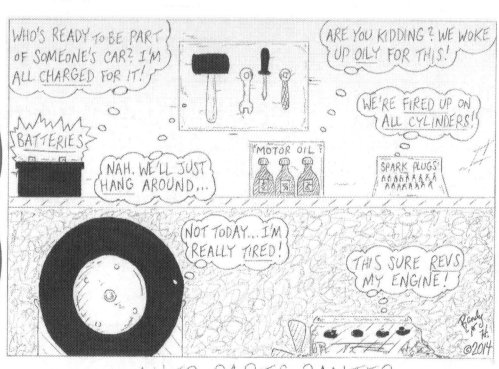

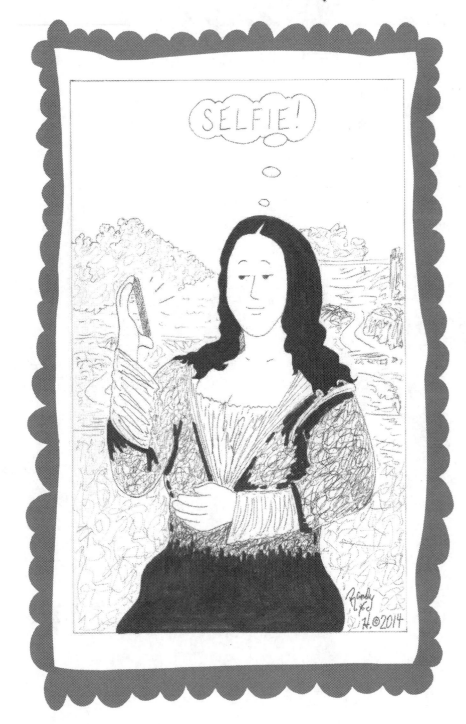

166

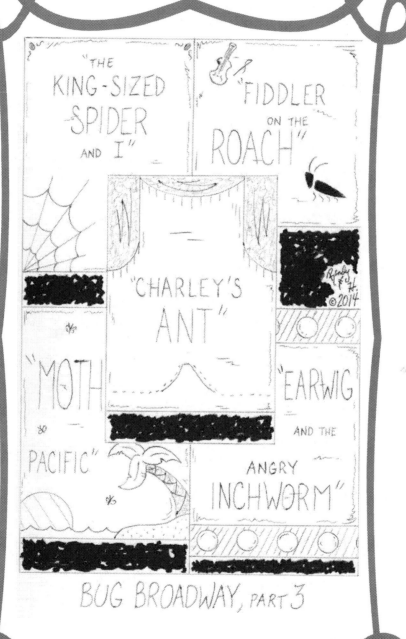

BUG BROADWAY, PART 3

HOSTED BY
FORREST GRANGER

Randy
H. ©2014

"WELCOME TO ANOTHER FUN EDITION OF 'BARKING UP THE WRONG TREE!' TODAY'S FEAT-
URED DOG JUST LIVES TO BARK UP TREES! LET'S SEE WHAT HAPPENS WHEN WE PUT A LIVE
WILDCAT UP THERE! BOY, WON'T DIGGER BE IN FOR A SURPRISE...!"

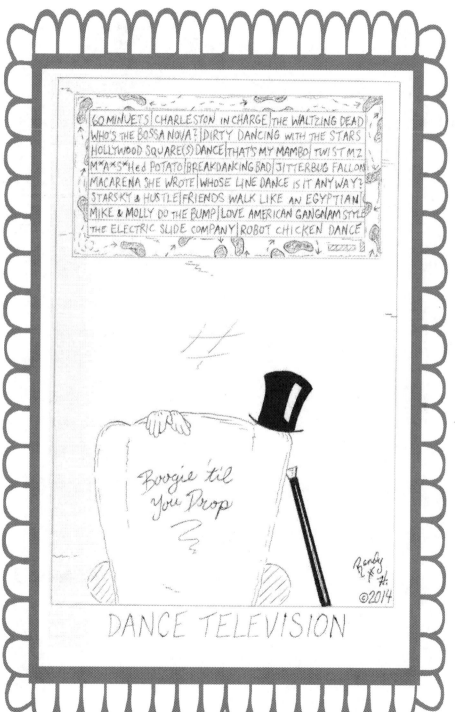

60 MINUETS | CHARLESTON IN CHARGE | THE WALTZING DEAD
WHO'S THE BOSSA NOVA? | DIRTY DANCING WITH THE STARS
HOLLYWOOD SQUARE(S) DANCE | THAT'S MY MAMBO | TWIST MZ
M*A*S*Hed POTATO | BREAKDANCING BAD | JITTERBUG FALLON
MACARENA SHE WROTE | WHOSE LINE DANCE IS IT ANYWAY?
STARSKY & HUSTLE | FRIENDS WALK LIKE AN EGYPTIAN
MIKE & MOLLY DO THE BUMP | LOVE AMERICAN GANGNAM STYLE
THE ELECTRIC SLIDE COMPANY | ROBOT CHICKEN DANCE

Boogie 'til
You Drop

©2014

DANCE TELEVISION

169

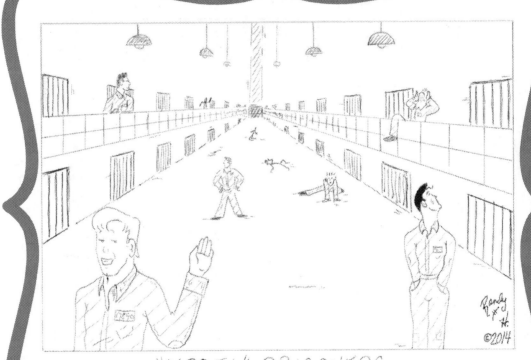

"MODEL" PRISONERS

ALL THE WORLD'S
AN
ABBOTT & COSTELLO
ROUTINE
(BUD AND LOU IN MODERN TIMES)

LOU (POINTING): "HEYY YAAABOTT! WHAT'S THIS GIZMO?"
BUD: "; PHONE!"
LOU: "WHO ARE YOU PHONING?"
BUD (GROWING IMPATIENT): "I'M TELLING YOU! ; PHONE!"
LOU: "IT'S YOUR CALL, BUDDY! WHAT ARE YA YELLIN' AT ME FOR?!"

BUD (EXPLAINING HIS TAX TROUBLES): "...AND THEN THE IRS PUT A
 LIEN ON MY PROPERTY..."
LOU (INTERRUPTING): "LEAN AGAINST WHAT?"
BUD: "MY HOME."
LOU: "SO, A LEAN AGAINST YOUR HOUSE MAKES THE IRS HAPPY?"
BUD: "EXACTLY!"
LOU (EXASPERATED): "EXACTLY? I DON'T EVEN KNOW WHAT WE'RE
 TALKIN' ABOUT!!"

LOU (WATCHING T.V.): "HEY BUD, WHAT'S THIS SHOW CALLED?"
BUD: "HOW I MET YOUR MOTHER."
LOU: "HOW'S SHE DOING?"
BUD (CONFUSED): "WHO?"
LOU: "MY MOTHER."
BUD: "WHAT? YOU DON'T GET IT! IT'S 'HOW I MET YOUR MOTHER'!"
LOU: "WHAT DOES MEETING MY MOM HAVE TO DO WITH THE SHOW?!"
 (BUD SLAPS LOU)

Randy Vtch ©2014

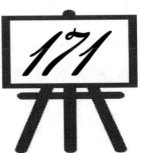

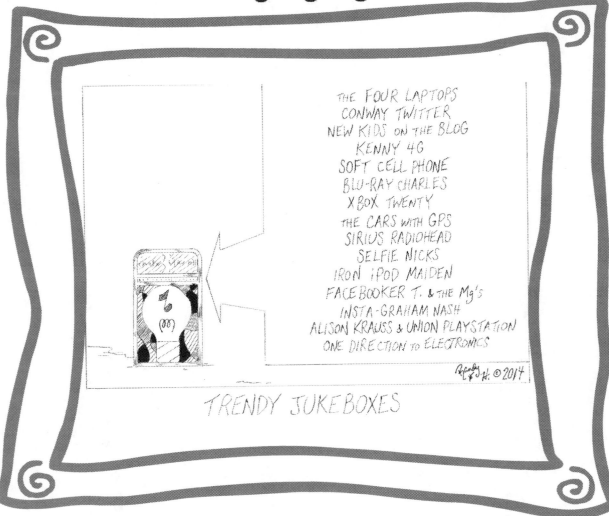

THE FOUR LAPTOPS
CONWAY TWITTER
NEW KIDS ON THE BLOG
KENNY 4G
SOFT CELL PHONE
BLU-RAY CHARLES
X BOX TWENTY
THE CARS WITH GPS
SIRIUS RADIOHEAD
SELFIE NICKS
IRON iPOD MAIDEN
FACEBOOKER T. & THE Mg's
INSTA-GRAHAM NASH
ALISON KRAUSS & UNION PLAYSTATION
ONE DIRECTION TO ELECTRONICS

TRENDY JUKEBOXES

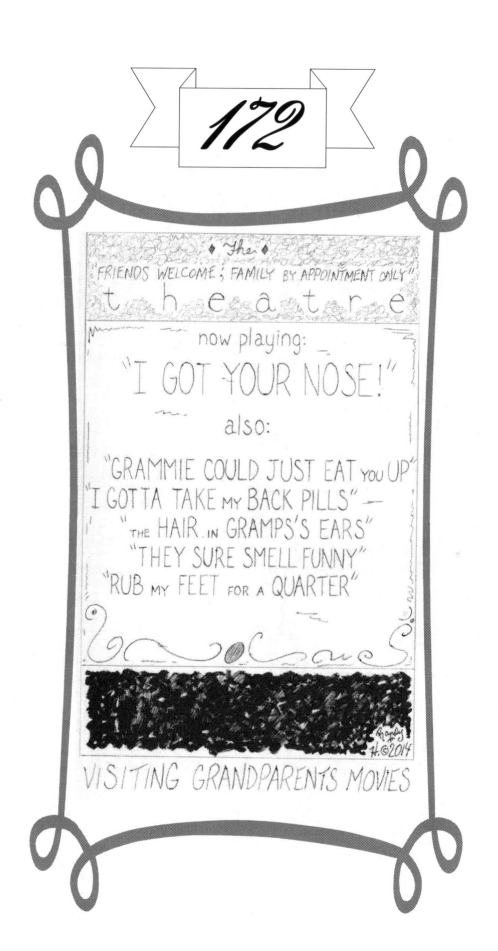

◆ The ◆
"FRIENDS WELCOME ; FAMILY BY APPOINTMENT ONLY"
t h e a t r e

now playing:
"I GOT YOUR NOSE!"

also:

"GRAMMIE COULD JUST EAT YOU UP"
"I GOTTA TAKE MY BACK PILLS"
"THE HAIR IN GRAMPS'S EARS"
"THEY SURE SMELL FUNNY"
"RUB MY FEET FOR A QUARTER"

VISITING GRANDPARENTS MOVIES

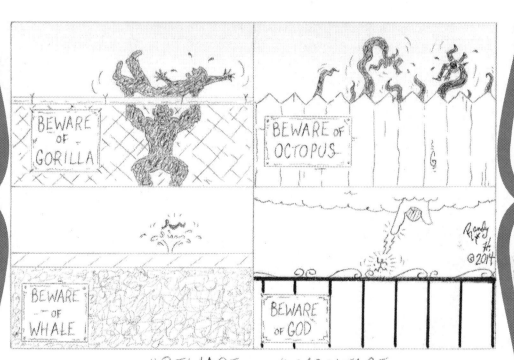

THE "BEWARE OF..." MONTAGE

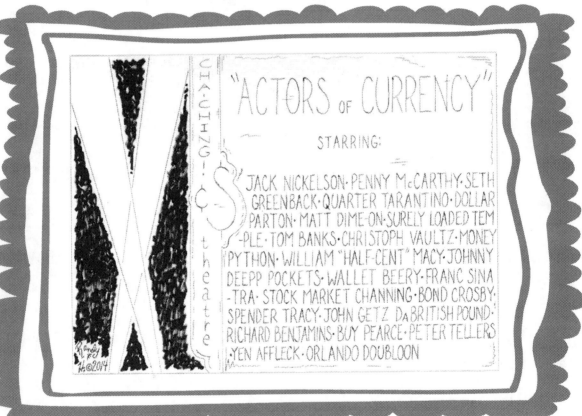

VIKING-C theatre

"ACTORS of CURRENCY"

STARRING:

JACK NICKELSON·PENNY McCARTHY·SETH GREENBACK·QUARTER TARANTINO·DOLLAR PARTON·MATT DIME·ON·SURELY LOADED TEM -PLE·TOM BANKS·CHRISTOPH VAULTZ·MONEY PYTHON·WILLIAM "HALF·CENT" MACY·JOHNNY DEEPP POCKETS·WALLET BEERY·FRANC SINA -TRA·STOCK MARKET CHANNING·BOND CROSBY· SPENDER TRACY·JOHN GETZ Da BRITISH POUND· RICHARD BENJAMINS·BUY PEARCE·PETER TELLERS ·YEN AFFLECK·ORLANDO DOUBLOON

178

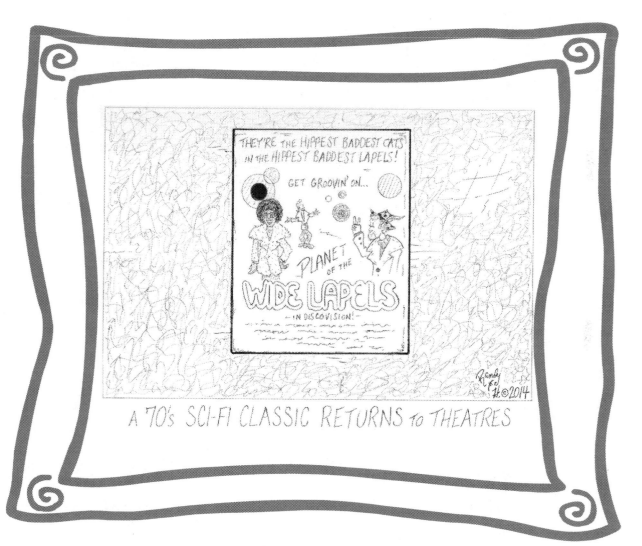

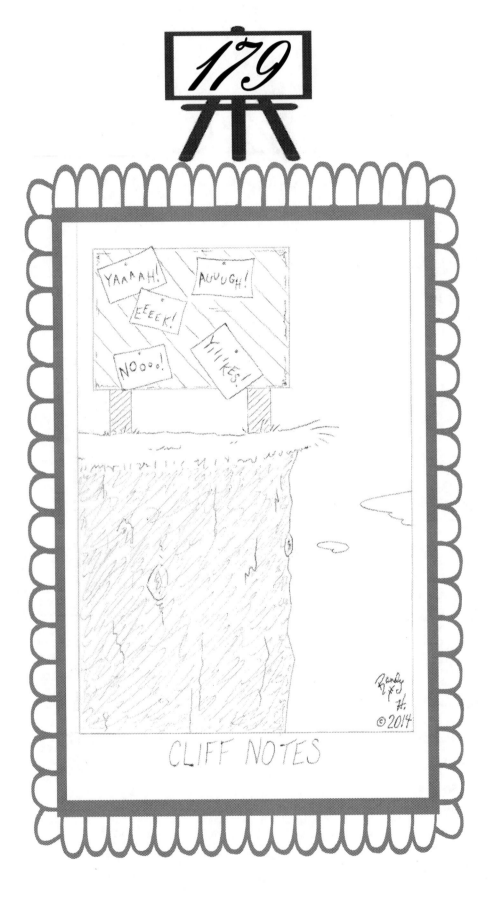

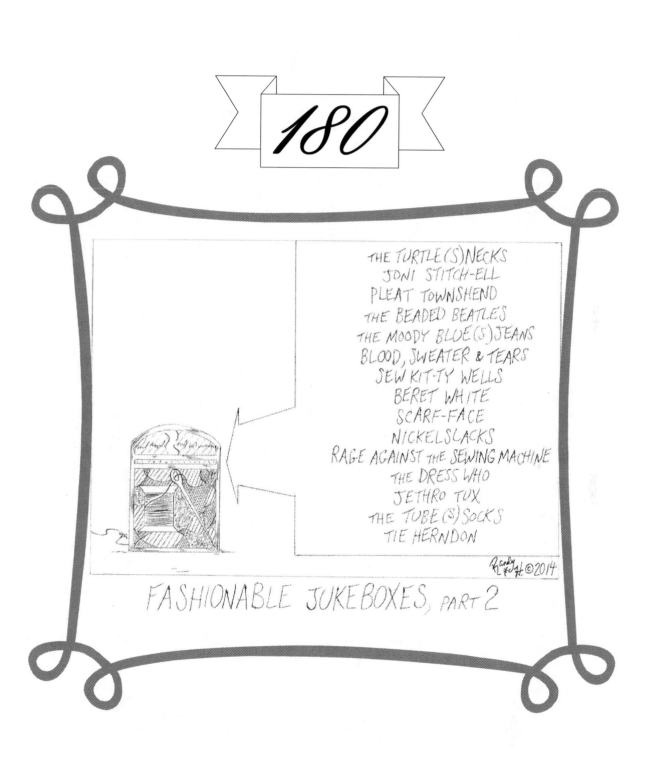

FASHIONABLE JUKEBOXES, PART 2

181

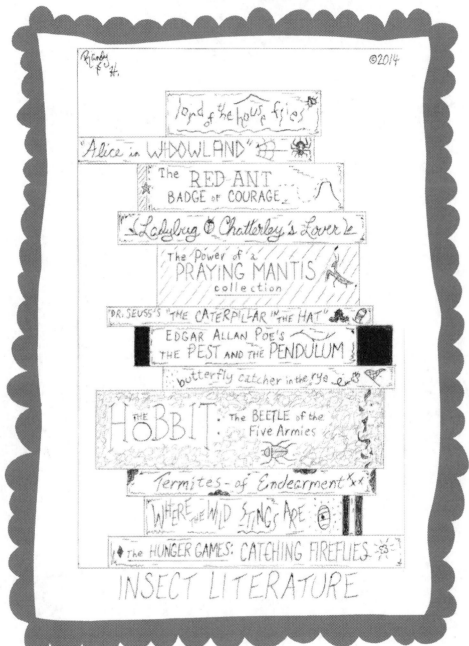

INSECT LITERATURE

182

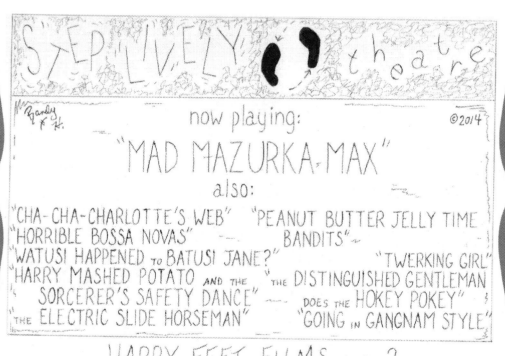

STEP LIVELY theatre

now playing:
©2014

"MAD MAZURKA-MAX"

also:

"CHA-CHA-CHARLOTTE'S WEB" "PEANUT BUTTER JELLY TIME
"HORRIBLE BOSSA NOVAS" BANDITS"
"WATUSI HAPPENED TO BATUSI JANE?" "TWERKING GIRL"
"HARRY MASHED POTATO AND THE THE DISTINGUISHED GENTLEMAN
 SORCERER'S SAFETY DANCE" DOES THE HOKEY POKEY"
THE ELECTRIC SLIDE HORSEMAN" "GOING IN GANGNAM STYLE"

HAPPY FEET FILMS, PART 2

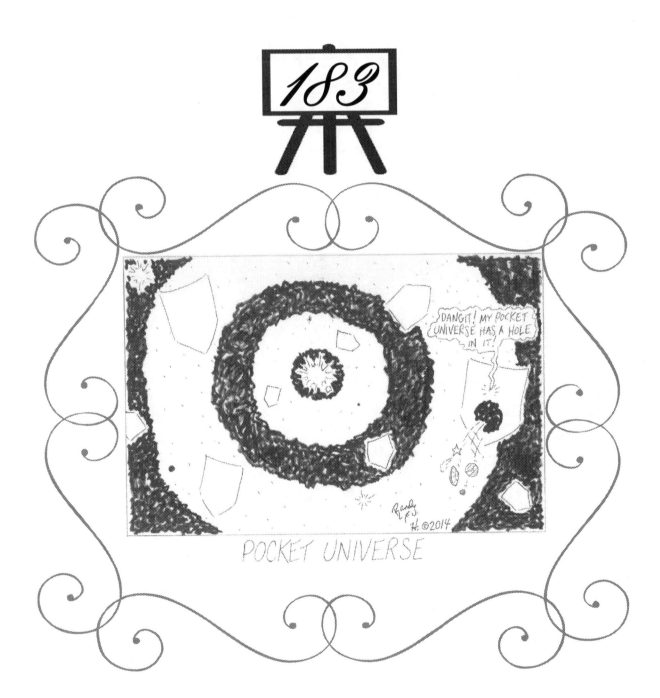

POCKET UNIVERSE

185

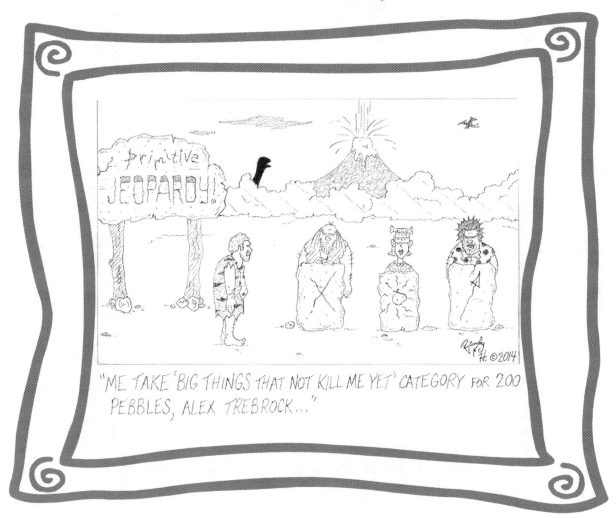

"ME TAKE 'BIG THINGS THAT NOT KILL ME YET' CATEGORY FOR 200 PEBBLES, ALEX TREBROCK..."

CHINESE DRAGON BALL Z | WHEEL OF FORTUNE COOKIES
SUDDENLY SUSHI | THE MANGA FROM U.N.C.L.E. | THE TOKYO OFFICE
SONS OF ANIME | CHOW MEIN SCANDAL | JIMMY KIMONO LIVE!
THE GOLDEN GEISHAS | MY SISTER SAMURAI | MIAMI RICE | NE
KNIGHT RICKSHAW RIDER | GREEN JAPANESE GARDEN ACRES
ORANGE CHICKEN IS THE NEW BLACK | SUMO-NATURAL | MAD YEN | M
THIS OLD BATH HOUSE | THE EGG FOO YOUNG & THE RESTLESS |
THE PEKING OF QUEENS | THE MOD SQUID | SAKE NIGHT LIVE | A

电 礻 见

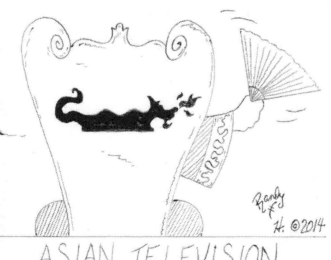

ASIAN TELEVISION

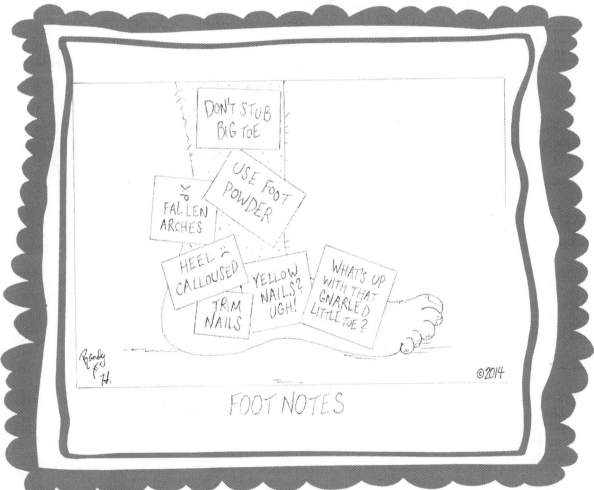

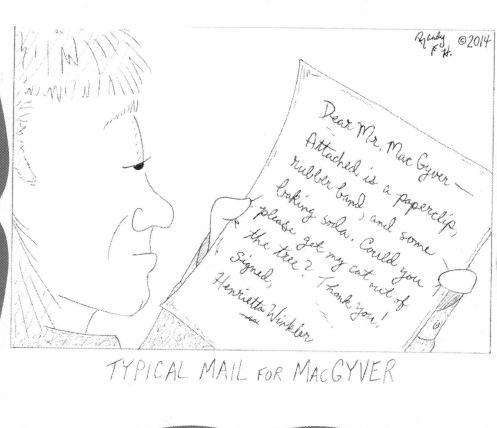

189

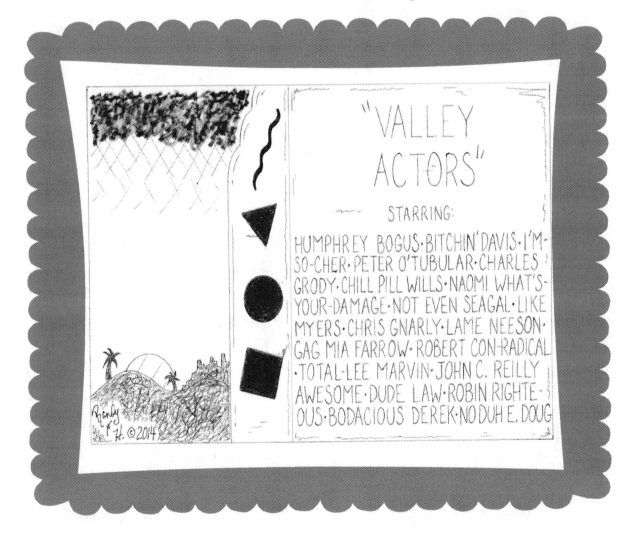

"VALLEY ACTORS"

STARRING:

HUMPHREY BOGUS·BITCHIN'DAVIS·I'M-
SO-CHER·PETER O'TUBULAR·CHARLES
GRODY·CHILL PILL WILLS·NAOMI WHAT'S-
YOUR-DAMAGE·NOT EVEN SEAGAL·LIKE
MYERS·CHRIS GNARLY·LAME NEESON·
GAG MIA FARROW·ROBERT CON-RADICAL
·TOTAL-LEE MARVIN·JOHN C. REILLY
AWESOME·DUDE LAW·ROBIN RIGHTE-
OUS·BODACIOUS DEREK·NO DUH E. DOUG

Randy
H. © 2014

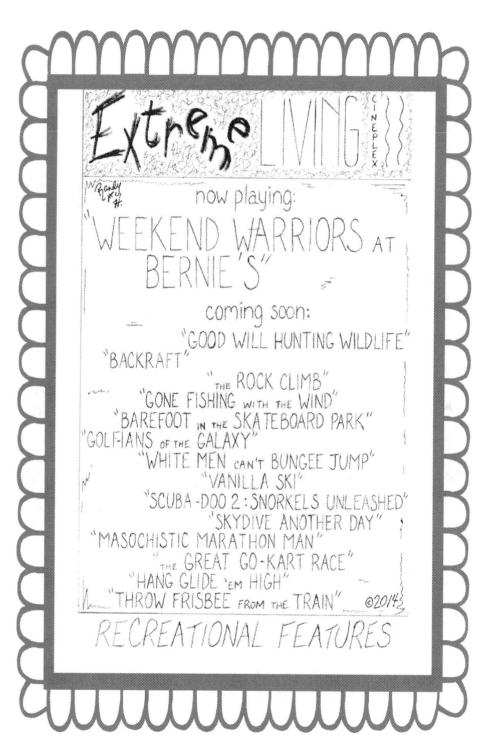

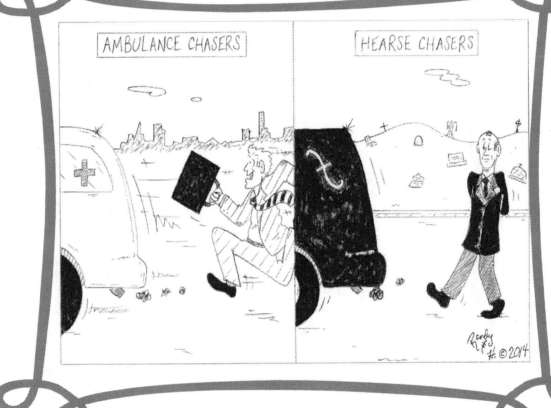

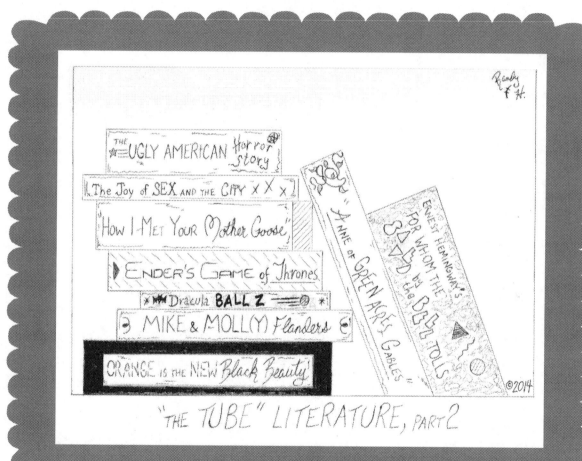

"THE TUBE" LITERATURE, PART 2

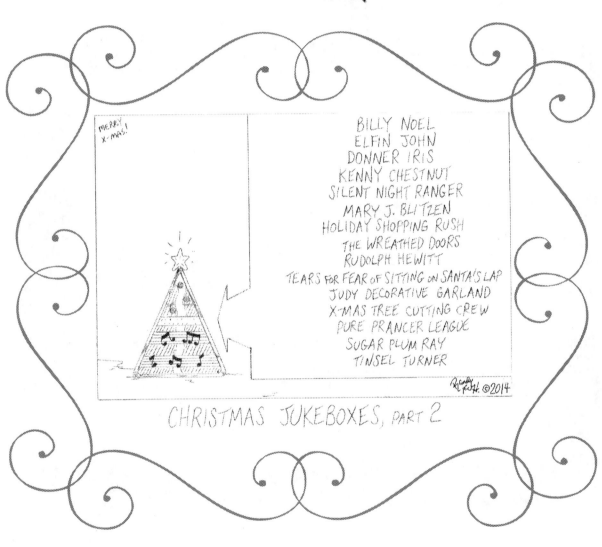

CHRISTMAS JUKEBOXES, PART 2

194

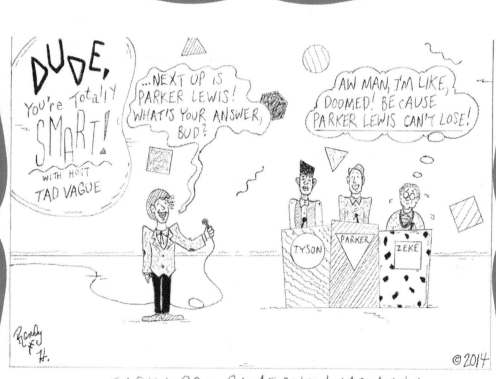

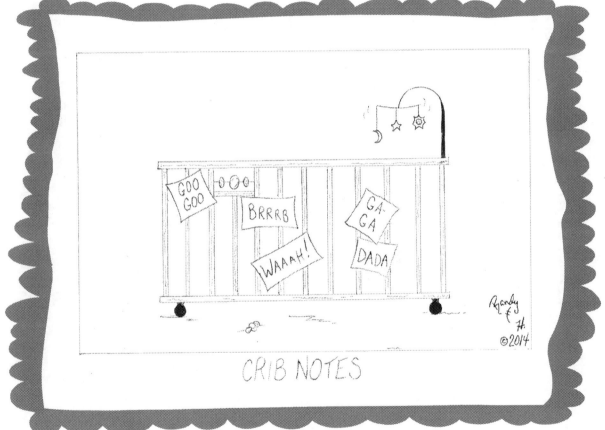

"SPORTY ACTORS"

STARRING:

HOCKEY BOGART · LUCILLE BASEBALL · JEREMY GRIDIRONS · CRAIG TEE-OFF NELSON · DENNIS HOOPSTER · RUN HOWARD · JERSEY LEWIS · NF-ELLEN DEGENERES · CLEAT EASTWOOD · LISA LINK · VERONICA LAKERS · GLORIA SWAN-DIVE · TENNIS QUAID · SOCCER L. JACKSON · GOALIE HAWN · WWF RING-O STARR · TERI WATERPOLO · BRUCE BOXER-LEITNER · LESLEY-ANNE TOUCHDOWN · BEN RIGHT CROSS · REDD SOX FOXX · NASCAR-RIE FISHER · JIM-NASTICS CARREY · VOLLEYBALL KIL-MER · BRAD PITT-SBURGH STEELERS · EDDIE SU-RFY · DON DWAYNE JOHNSON · ANGELA BACKSTROKE

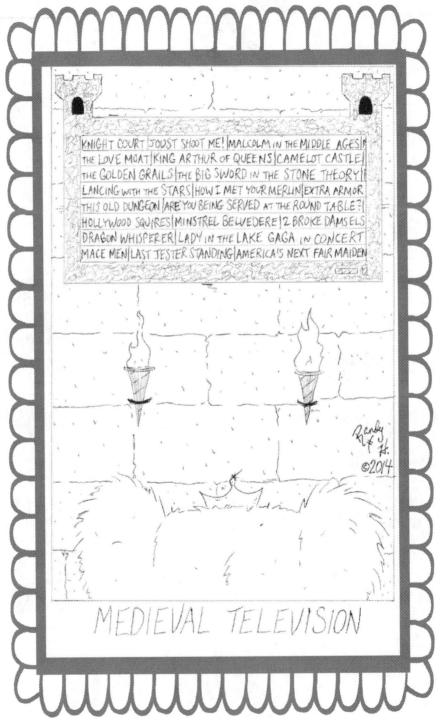

KNIGHT COURT | JOUST SHOOT ME! | MALCOLM IN THE MIDDLE AGES | IN THE LOVE MOAT | KING ARTHUR OF QUEENS | CAMELOT CASTLE | THE GOLDEN GRAILS | THE BIG SWORD IN THE STONE THEORY | LANCING WITH THE STARS | HOW I MET YOUR MERLIN | EXTRA ARMOR | THIS OLD DUNGEON | ARE YOU BEING SERVED AT THE ROUND TABLE? | HOLLYWOOD SQUIRES | MINSTREL BELVEDERE | 2 BROKE DAMSELS | DRAGON WHISPERER | LADY IN THE LAKE GAGA IN CONCERT | MACE MEN | LAST JESTER STANDING | AMERICA'S NEXT FAIR MAIDEN

©2014

MEDIEVAL TELEVISION

198

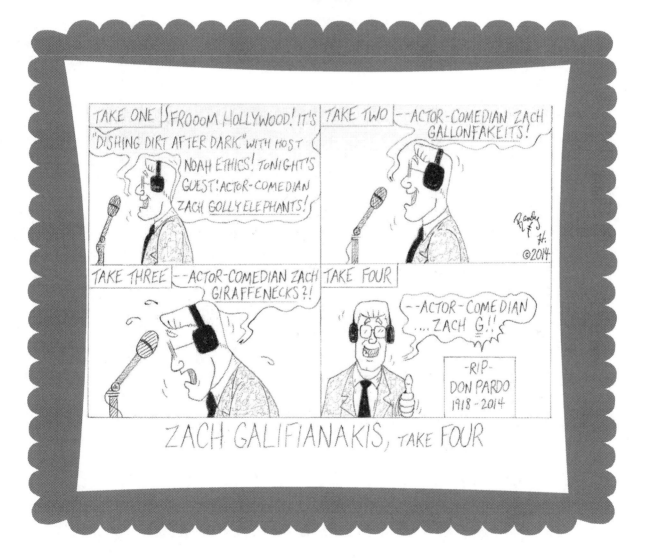

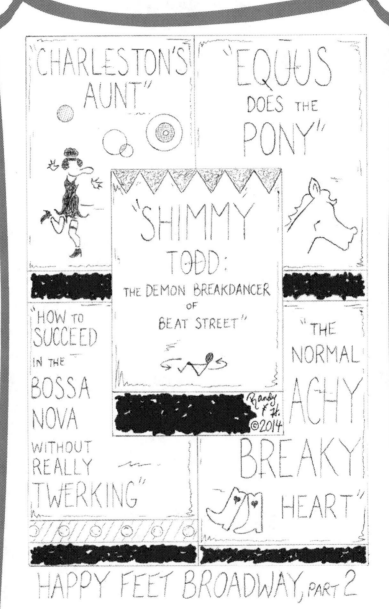

200

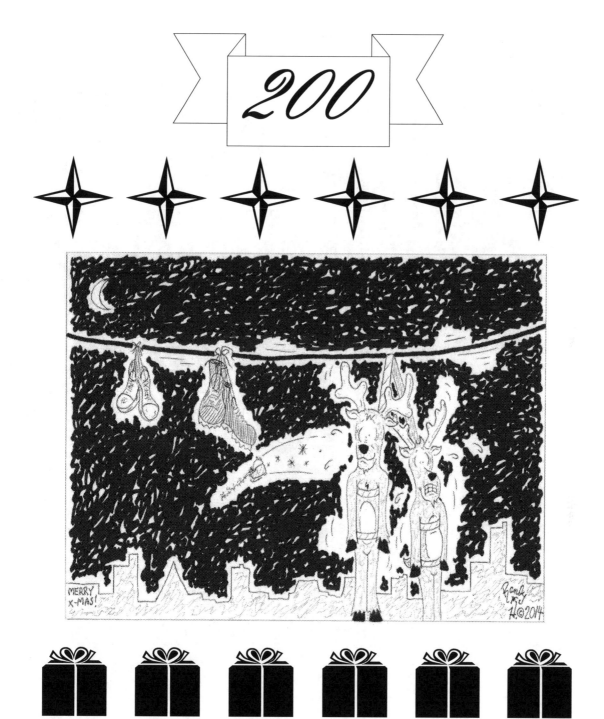

The End

Author

Being an "anniversary" book, it was only fitting that my photographer
share the spotlight. She hopped on the *Left Field* bus with Book #5,
and has been on board ever since.
Not to mention that she also happens to be my lovely niece.
Thank you for your keen talented eye and intuitive style, Shelby
Rose Foster.
Your Uncle loves you much!

Printed in the United States
By Bookmasters